Wild Bird Photography

NATIONAL AUDUBON SOCIETY GUIDE

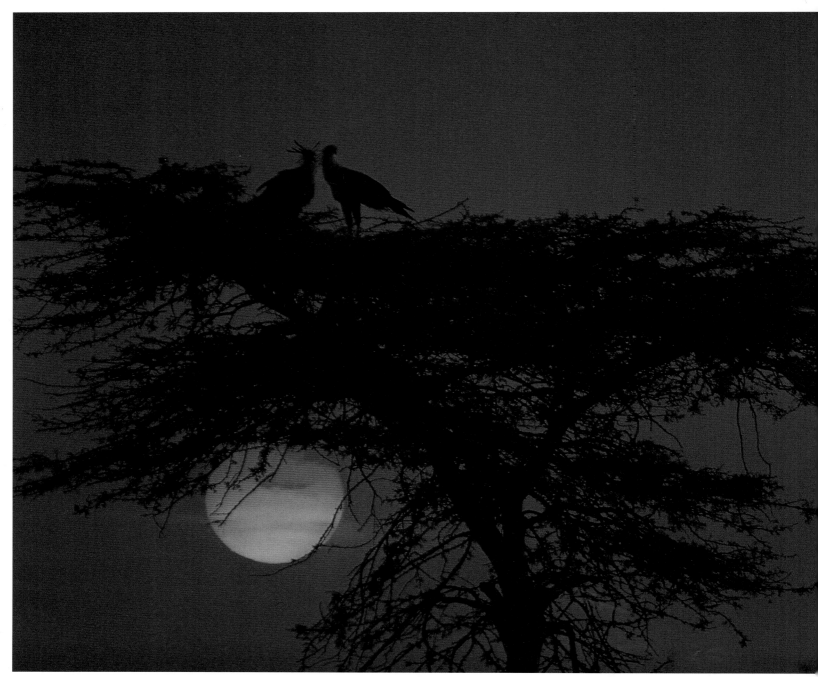

Secretary Birds at Nest, Serengeti Plains, Kenya

Wild Bird Photography

NATIONAL AUDUBON SOCIETY GUIDE

Text and Photographs by
Tim Fitzharris

FIREFLY BOOKS

A FIREFLY BOOK

Cataloguing in Publication Data

Fitzharris, Tim, 1948—
 Wild Bird Photography: National Audubon Society Guide
ISBN 01-55209-018-3
1. Nature photography — Handbooks, manuals, etc.
2.Birds. I. Title.
TR729.B5F5 1996 778'.932 C95—933027-5

National Audubon Society is a trademark of the National Audubon Society, Inc.

Production Co-ordinator: Joy Sambilad Fitzharris

Published by Firefly Books

Firefly Books Firefly Books (U.S.) Inc.
3680 Victoria Park Avenue P.O. Box 1338
Willowdale, Ontario Ellicott Station
Canada M2H 3K1 Buffalo, New York 14205

Printed in Hong Kong

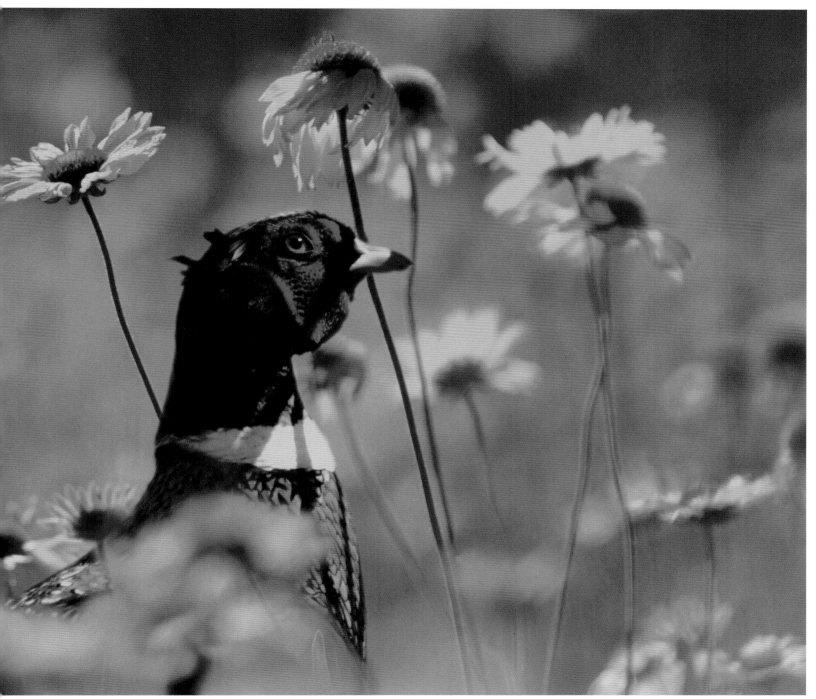

Ring-necked Pheasant, New Mexico (digitally composed image)

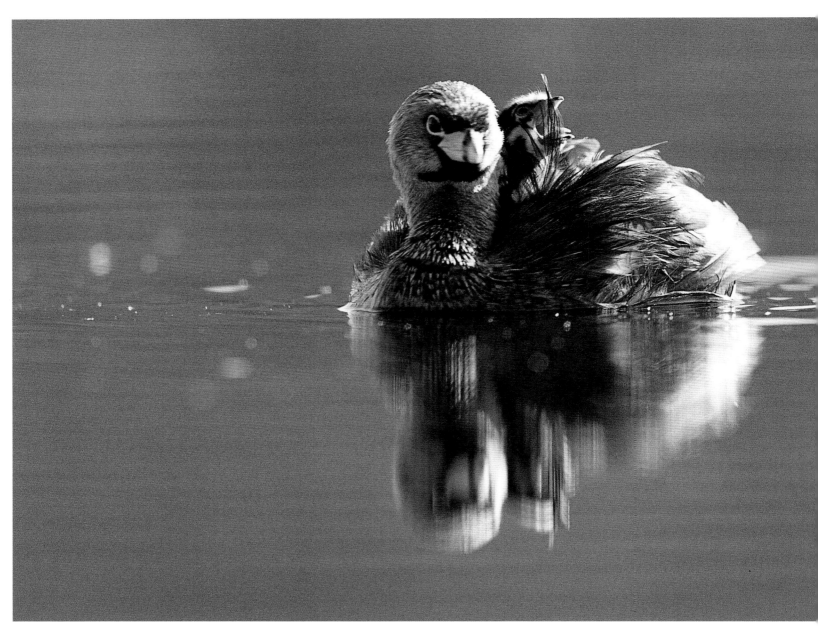

Pied-billed Grebes, Stinking Lake, New Mexico

The mission of **NATIONAL AUDUBON SOCIETY** is to conserve and restore natural ecosystems, focusing on birds and other wildlife for the benefit of humanity and the earth's biological diversity.

In the vanguard of the environmental movement, **AUDUBON** has more than 500,000 members, 14 regional and state offices, and an extensive chapter network in the United States and Latin America, plus a professional staff of scientists, lobbyists, lawyers, policy analysts, and educators.

Through our nationwide sanctuary system we manage 150,000 acres of critical wildlife habitat and unique natural areas for birds, wild animals, and rare plant life.

Our award-winning *Audubon* magazine, published six times a year and sent to all members, carries outstanding articles and color photography on wildlife and nature, and presents in-depth reports on critical environmental issues, as well as conservation news and commentary. We also publish *Field Notes*, a journal reporting on seasonal bird sightings continent-wide, and *Audubon Adventures*, a bimonthly children's newsletter reaching 600,000 students.

Our acclaimed *World of Audubon* television documentaries deal with a variety of environmental themes. **NATIONAL AUDUBON SOCIETY** also sponsors books and electronic programs on nature, plus travel programs to exotic places like Antarctica, Africa, Australia, Baja California, Galapagos Islands, Indonesia, and Patagonia.

For information about how you can become a member, please write or call:

<div align="center">

NATIONAL AUDUBON SOCIETY
Membership Dept.
700 Broadway
New York, NY 10003
(212) 979-3000

</div>

In Memory of Gordon Sherman

Books by Tim Fitzharris

Nature Photography: National Audubon Society Guide

Fields of Dreams: Travels in the WIldflower Meadows of America

Soaring with Ravens: Visions of the Native American Landscape

The Equinox/Sierra Club Guide to 35 mm Landscape Photography

Coastal Wildlife of British Columbia (with Bruce Obee)

Wild Wings: An Introduction to Birdwatching

Forest: A National Audubon Society Book

Wild Birds of Canada

Canada: A Natural History (with John Livingston)

British Columbia Wild

Wildflowers of Canada (with Audrey Fraggalosch)

The Wild Prairie: A Natural History of the Western Plains

The Adventure of Nature Photography

The Island: A Natural History of Vancouver Island

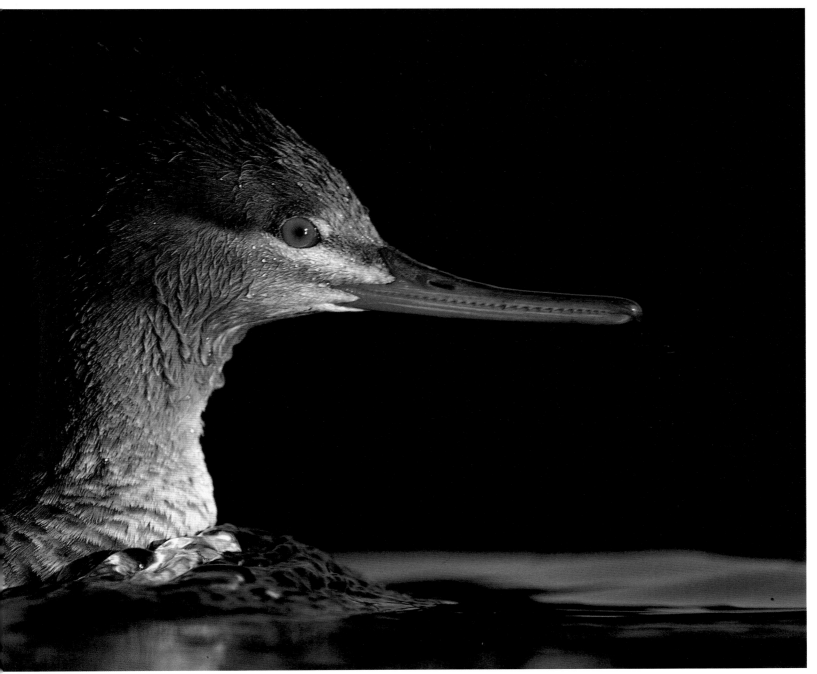

Red-breasted Merganser, Vancouver Island

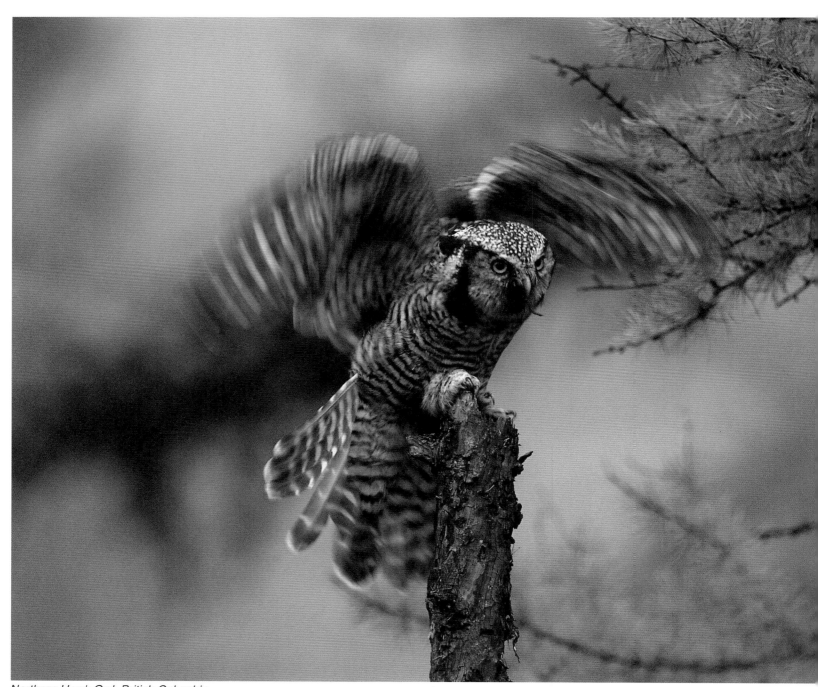

Northern Hawk Owl, British Columbia

Table of Contents

Exploring Aesthetic Horizons

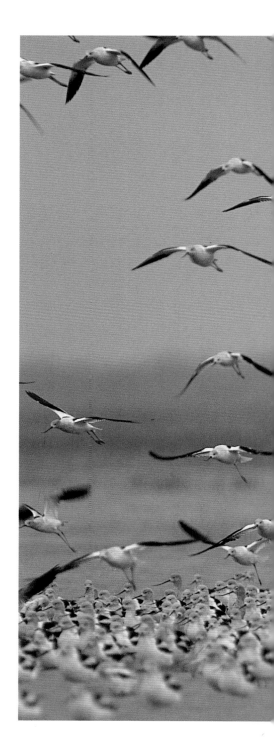

EVERYTHING IS GRAY. The sand, the rumpled sky, the water. And the birds— avocets in winter plumage, thousands of them massed in a single-minded flock. All of it is in my viewfinder. Suddenly a wall of gray seethes upward into the atmosphere. My finger twitches and the motor drive chatters, breaking the tension. The beach is suddenly empty but I know I have gotten some good pictures. In less than a minute, fragile creatures begin to settle out of the swirling storm of feathers overhead, alighting again almost in front of me, floating to earth on mothy wings, a shower of nervous angels. Or so it seems.

As I recall this foggy morning on the Texas coast, I hear over the radio that a United Nations report has listed over 5,000 animals as endangered species. Most of these creatures will disappear from our planet forever. The reported cause is loss of habitat to human activity. It is a story we have heard unchanged for decades. There

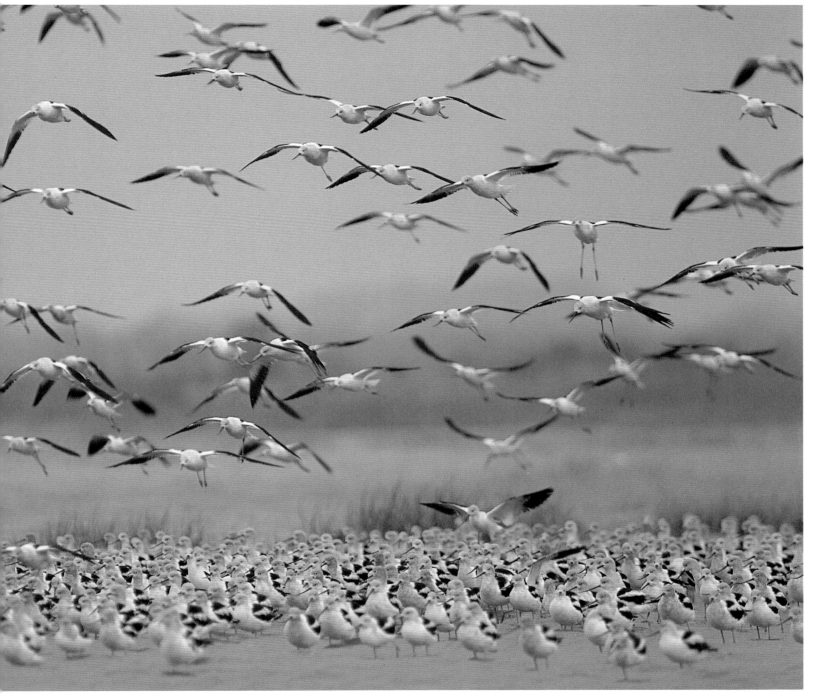

American Avocets, Bolivar Flats, Texas

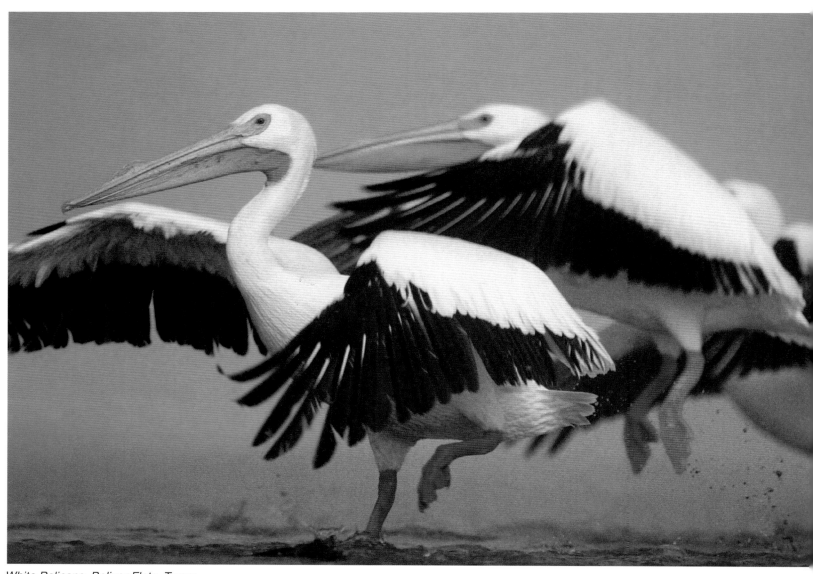

White Pelicans, Bolivar Flats, Texas

are some successes to celebrate here in North America—the bald eagle, the trumpeter swan, and the brown pelican. Yet even the reprieve of these species may be only temporary in face of the worldwide deterioration of natural ecosystems.

Bird photography is a way of encouraging public appreciation of nature and focusing attention on critical environmental issues. It not only will strengthen your own connection with the wild, but the products of your work can become persuasive instruments of social change whether exhibited within a circle of family and community or published in commercial media.

Many bird photographers ply their craft in deservedly popular refuges, such as Ding Darling or Bosque del Apache, venturing not far from their vehicles, massed tripod to tripod, targeting the latest cameras and lenses at avian subjects. This is a good and committed beginning to an undertaking whose rewards can be even greater.

This guide is for those who wish to explore the aesthetic horizons of bird photography, an undertaking that will transport you into green confines where you will be touched by beauty—the crimson glint of a puffin's bill, the turbulence of a passing hummingbird against your cheek, or the first tentative twitter of a lark at sunrise. This book will show you how to photograph unobtrusively in intimate contact with your subjects; a territory not often travelled by others. It can be found not only in our national parks and refuges, but in your own neighborhood, in your backyard, in the wood lot at the end of the street, and in a thousand other quiet places of little notoriety. What you learn in private tutelage from the roadrunner and the dowitcher can be shared with others through your photographs.

I have passed many contented hours in solitary redoubts, watching, listening, and photographing when opportunity permitted. In recent years I have relived happily some of these experiences in front of a computer screen, combining, through digital imaging techniques, the light that nature once shone on the lens with that which was recorded but fondly in my memory. With the computer, I can remove a twig that once obscured, light up plumage that the sun would not, or gather a flock that had become dispersed. Unlike some technological advances, computer imaging enriches the creative experience. This book will get you started in this relatively new dimension of the photographer's art.

No principled photographer of birds would ever knowingly harm or cause discomfort to his subjects. Nevertheless, this can happen if you do not gain the necessary understanding of avian behavior patterns, especially their tolerance to human approach. This knowledge is your best tool in safeguarding birds from the inadvertent disturbance that your photographic endeavors can cause. The degree to which you accept this responsibility is evidence of the sincerity of your concern for nature. Such preparation is even more critical for photographers who may choose to photograph at the nest, something which should only be attempted by those with advanced skills and knowledge, and extensive ornithological field experience. Understanding your subject is also a fundamental key to successful bird photography.

The earth is still mostly a beautiful ball of blue water and sighing forests, mother to penguins, kangaroos, and hammerhead sharks; a tiny planet drifting in a limitless cosmos—it is our sweet home, a warm and tolerant refuge for all that would share it. But the earth is sick, suffering from human over-population and accelerating destruction of its resources on all fronts. Environmental education and heightened public awareness of the natural world are critical forces that can drive the process of healing. With perseverance and a little inspiration, your photographs are sure to help.

Good shooting!

—*TF*

Special Equipment for Bird Photography

I T IS EASY TO SELECT a camera for bird photography despite the abundance of models available. Fortunately, such a camera also can be used to photograph all manner of subjects with outstanding results.

CAMERAS

The only camera you need to consider buying is the 35 mm single-lens-reflex (SLR). This type of camera is easily portable and fast handling. It accepts a wide range of accessories including super-telephoto lenses and close-up equipment.

BUYING A 35 MM SLR

When you buy a camera, you also are committing yourself to its system of lenses and accessories, a consideration of equal importance to the bird photographer. Based on efficient design, system extent, and reasonable price, these brands are recommended: Nikon, Canon, Minolta, Pentax, and Sigma. Canon and Nikon are used by the majority of professionals and offer the most extensive systems. Sigma is the least expensive. Advertising claims aside, there is nothing that will differentiate the quality of

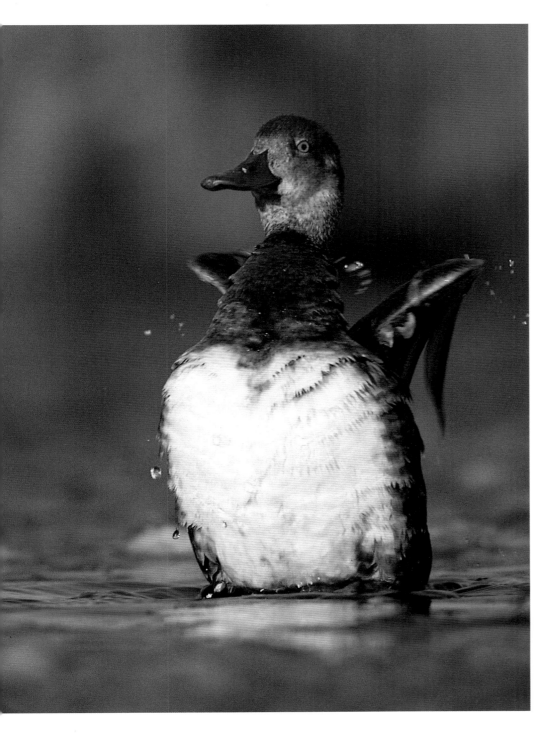

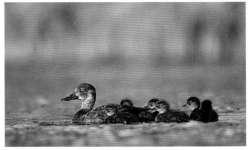

Lesser Scaup Ducks, Alberta. *This hen had brought her ducklings over the prairie to a slough not much bigger than the average backyard. I moved slowly into the water with camera and tripod, taking a number of exposures of the family as they swam back and forth in front of the camera. I followed the troop in the viewfinder tripping the shutter whenever I could attain sharp focus. The small camera, powerful telephoto lens, accurate viewfinder, high speed motor drive, and inexpensive 35 mm film format were all factors that allowed me to quickly make a selection of photographs from which these two were chosen. Nikon F2, 400 mm f/5.6 ED Nikkor, Kodachrome 64, 1/350 second at f/4.5.*

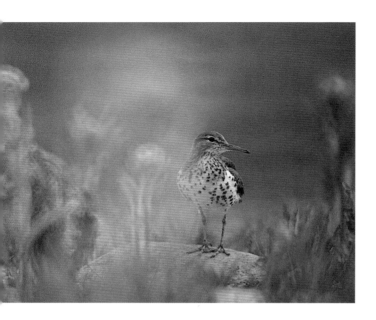

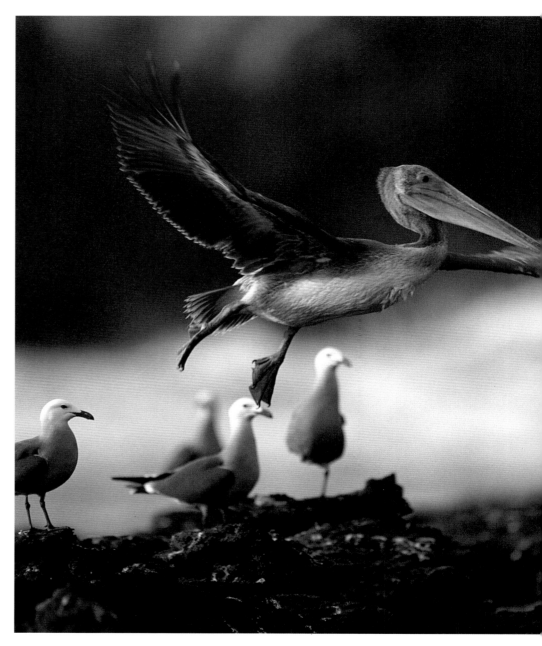

Spotted Sandpiper, Alberta. *The shallow depth of field of the telephoto lens allowed me to isolate the bird among the flowers. Concealed in a stationary blind, I followed the bird as it moved through the vegetation, evaluating the blurred and shifting overlays of background and foreground elements, waiting for the right moment to trip the shutter. Nikon F2, 500 mm f/8.0 Reflex Nikkor, Fujichrome 100, 1/500 second at f/8.*

Brown Pelican, Isla Isabel, Mexico. *With the camera set on aperture priority, automatic exposure, I used the exposure compensation dial to give the scene 1/2 stop more light in order to illuminate the shadow areas of the bird. Canon A2, 400 mm f/2.8 L Canon, Ektachrome Lumiere 100, 1/500 second at f/2.8.*

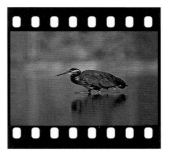

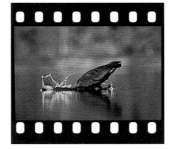

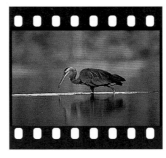

the imagery made by these various brands except the ability of the photographer. Make sure the camera has these features:

• *Depth-of-field preview.* This allows you to preview the scene at the aperture used during exposure, important because this aperture can be smaller than the aperture at which you view the scene in the viewfinder. When it is, the amount of the scene that is in sharp focus will be greater, an important design consideration which you will wish to evaluate before tripping the shutter.

• *High speed motor drive.* A motor drive advances the film at speeds up to five frames per second, even faster on special models. Faster is always better. When photographing a bird in action, especially in flight, the action happens too quickly for you to see. Usually, the strategy is to make as many exposures as possible, editing for the best images once the film is developed.

• *Convenient exposure compensation dial.* Usually a standard feature on auto-exposure cameras, this dial allows you to over-ride the exposure that is automatically set, usually necessary when the image is high in contrast (a light subject against a dark background) or when the main subject is strongly lit from behind.

• *Variable pattern light meter.* This allows you to choose the light measuring pattern that the meter will use for the scene—full screen average, center-weighted, and spot metering are common. Evaluative metering is a more recent method

Great Blue Heron Fishing, Vancouver Island.
The motor driven camera allowed me to record this fast breaking action at five frames per second. Canon T90, 500 mm f/4.5 L Canon, Kodachrome 64, 1/250 second at f/4.5.

19

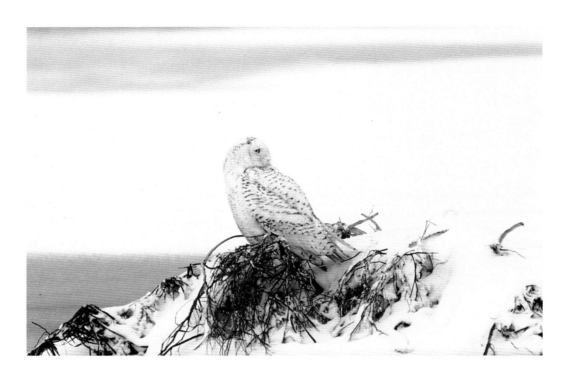

which takes six to ten area readings instantaneously and then makes comparative evaluations of the readings before setting exposure. This system is intended to compensate automatically for high contrast and backlit situations. The best combination is full-screen average, spot, and evaluative. If the camera only offers one metering pattern, spot or center-weighted metering are preferred.

Other features important to the bird photographer, such as interchangeable lenses, high speed shutter, and accurate viewing, are standard on nearly all 35 mm SLR cameras. Automatic film rewind, automatic film speed indexing, automatic film loading, interchangeable focusing screens, and built-in flash are not essential but they make shooting faster and more convenient.

AUTO-FOCUS CAMERAS

Despite great advances in auto-focusing accuracy, this feature usually is of little use to the bird photographer. Human nature requires that the bird's eye be sharply focused in a photograph and currently there is no way to insure this except to do it manually.

Nevertheless, these cameras are preferable, for along with auto-focusing, they offer lighter weight, more lens choices, more accurate metering systems, and many other convenient automatic features. Of particular value to the bird photographer, their motor drives and film rewinders are quieter than those of older manual

Snowy Owl, Alberta. *Spot metering an average area was necessary due to the brightness of the owl and background. I made an automatic reading near the circled area, kept the shutter button partially depressed to lock in the settings, and then re-framed the scene for better composition.*

Screech Owl, British Columbia. *Because this scene is low in contrast, all metering patterns would produce about the same exposure. However, the general luminence values are lower than average so I used the exposure compensation dial to manually reduce exposure by 1/2 stop in order to retain the rich, dark tones.*

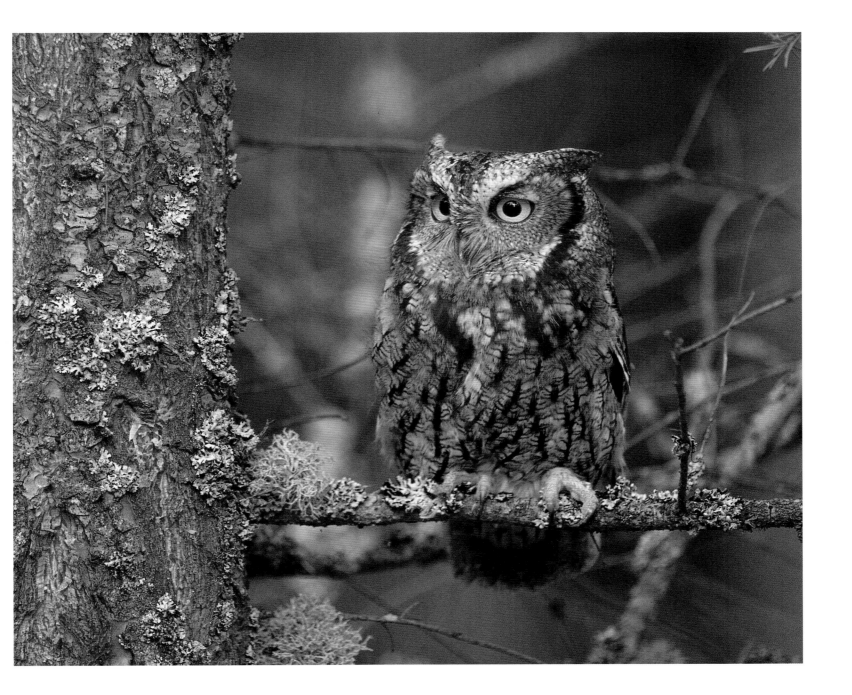

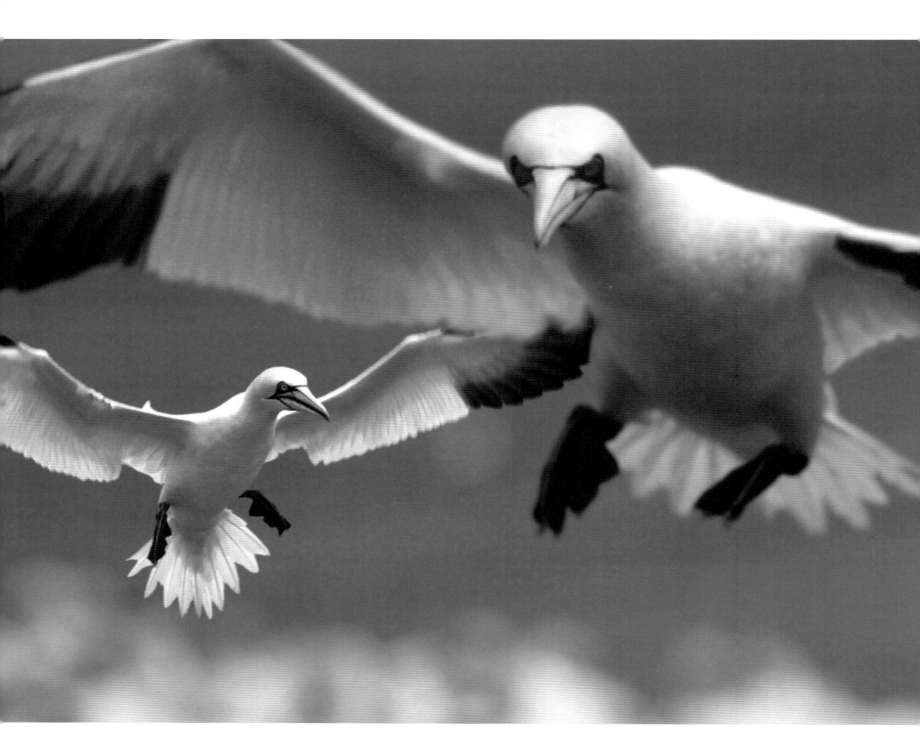

focus cameras. Auto focusing may prove more useful than manual focus when operating the camera remotely or shooting birds in flight. If you buy a camera with auto-focus, and I strongly recommend that you do, make sure that it has convenient provision for manual focus.

BUYING BY MAIL

You will save considerably by buying your equipment and film from mail order houses. They advertise their wares in most photography magazines. Generally you can return any equipment for a full refund, no questions asked, within ten days of receipt. It is easy to get complete information about equipment from manufacturers, photography magazines, and local photo shops before placing an order. Unlike a local camera store, a large mail order company stocks nearly all of the products of the major camera manufacturers, making it easy to obtain specialized equipment or accessories quickly.

Northern Gannets, Bonaventure Island, Quebec. I photographed these gannets as they were returning to their crowded nesting rookery using the manual 'trap' focus technique. This is done by pre-focusing the lens so that the desired magnification of the subject is achieved and then following the bird as it approaches, tripping the shutter an instant before it reaches maximum sharpness in the viewfinder. These birds were scanned from separate images and combined using digital imaging techniques. Nikon F2, 200 mm f/4 Nikkor, Kodachrome 64, 1/500 second at f/5.6.

🦆 BONAVENTURE ISLAND *PHOTO HOTSPOT*

A SMALL, uninhabited island off the tip of Quebec's Gaspé Peninsula, Bonaventure is site of one of the most accessible and spectacular seabird colonies in North America. During the summer, tens of thousands of northern gannets, along with smaller numbers of Atlantic puffins, razorbills, common murres, black-legged kittiwakes, black guillemots, and various gull species form breeding colonies on the rocky seaward-facing cliffs.

To reach Bonaventure, located three kilometers (two miles) offshore, you must take one of the frequent ferries from the quaint French Canadian village of Percé. The

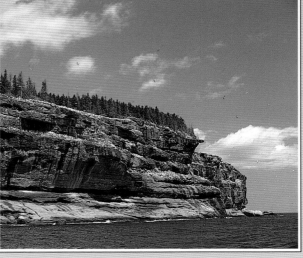

boat circles the Island before landing to give visitors an ocean level view of the seventy-five meter (250 foot) cliffs where the birds nest. The trail across the island to the rookeries winds through balsam fir and spruce woods alive with breeding songbirds—Tennessee warblers, black-throated green warblers, magnolia warblers, hermit thrushes, fox sparrows, purple finches, and pine siskins.

The gannets are packed nearly shoulder-to-shoulder along the upper cliffs, spilling over onto the grassy knoll on top. A fence keeps observers from approaching the colony too closely, but in good years the birds spread beyond it. Breeding rituals, incubation, feeding the young, and the social organization of the colony can be photographed at leisure. It is a noisy scene of non-stop action and an excellent place to make flight shots of the gannets as they come into their nests. Focal lengths of 200 mm and longer are advisable.

This region is covered with northern spruce forests, a hotspot for nesting warblers and other songbirds. Be sure to walk out to Percé Rock at low tide where you will be rewarded with not only close views of this famous geologic formation, but guillemots, kittiwakes, gulls, and razorbills nesting in the cluttered rocks at the base of the cliff.

There are good motels, restaurants, and campgrounds in Percé, but it is advisable to make reservations in advance.

TELEPHOTO LENSES

Wild bird photography is done with telephoto lenses, usually in the 500 mm and greater (super telephoto) range. This lens should be the basis of your choice of a camera system. Despite its impressive size, you will be required to approach a wild bird closer than it will normally allow. Over 500 mm, longer is not necessarily better. When looking for a super telephoto lens, keep the following considerations in mind.

• *It should be easy to carry.* You will be following birds into their habitat, into rough and often wet terrain. You will be working in trees, on cliffs, and in marshes. Travelling fast and light will be more enjoyable and allow you to produce more top-quality pictures. For most people a telephoto should not weigh more than six or seven pounds.

• *The lens should have a maximum aperture of f/5.6 or larger.* A large aperture allows brief exposure times, yielding fast shutter speeds that will freeze the movement of a flighty subject. Unfortunately the larger the aperture, the heavier the lens.

• *The lens should have internal focusing.* Big lenses have heavy, front glass elements. With conventional focusing, these elements shift back and forth, throwing the lens and camera off balance and making it difficult to keep the subject correctly positioned in the viewfinder. Internal focusing maintains balance by shifting only lightweight elements at the rear of the lens near the camera.

• *The lens should have apochromatic elements.* Chromatic aberration (the inability of a lens to bring all colors of a scene into focus simultaneously) is inherent with telephoto focal lengths. Special glass elements which alleviate this problem are necessary on lenses 400 mm and longer. Such lenses are called apochromatic (APO) lenses. APO Nikon and Pentax lenses are designated as 'ED'; Canon designates theirs with an 'L'. Mirror lenses are not recommended. Although small and inexpensive, they produce images with peripheral darkening (vignetting) due to uneven transmission of light, render specular highlights as distracting donut shapes, and have a fixed aperture.

• *The auto-focus lens should have finger-touch manual override.* Auto-focus lenses cannot focus precisely on a bird's eye, a necessity in most detailed compositions. This needs to be done manually. Most auto-focus lenses have an on-off switch, but the best ones switch to manual focus automatically as soon as your finger touches the focus ring. Such a lens provides the fastest and most precise focusing. Auto-focusing brings the bird into focus almost instantaneously, and a slight pressure of your finger completes the fine tuning on the eye.

• *The lens should focus as close as possible.* Most birds are small creatures and you need to work close to them to get revealing pictures. The lens should produce at least a 1/8 life size image (a field of view 8 by 12 inches) at the closest focusing distance (about 12 feet with a 400 mm lens).

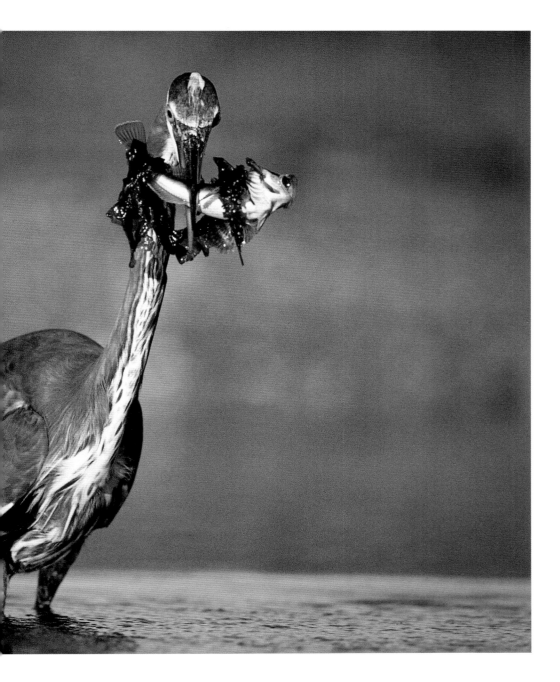

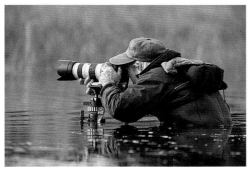

Great Blue Heron, Vancouver Island. *Nothing is more crucial to attaining all the detail your lens and film are capable of recording than the use of a sturdy tripod. With many subjects, mobility is also a key factor in drawing close enough and obtaining a dramatic camera angle. So although your tripod should be sturdy, it also should be light enough for you to move about easily. The weight of the camera and lens adds the mass necessary to dampen vibrations. Here I was working inside a mobile hoop blind (see Part IV, Elusive Subjects) in a tidal lagoon where herons congregate regularly when the tide is rising. The heron had no idea a human was present. Canon F1, 500 mm f/4.5 L Canon, Kodachrome 64, 1/500 second at f/4.5.*

Great Gray Owl, British Columbia. *Zoom lenses are valuable when recording birds as part of the wild habitat, a situation that requires precise framing of the landscape. Hazy light and a polarizing filter brought out the rich colors of the larch grove. Most owls can be cautiously approached in the open with lenses of 500 mm or greater. Canon A2, 100-300 mm f/5.6 L Canon set at about 200 mm, Fujichrome Velvia, 1/125 second at f/8.*

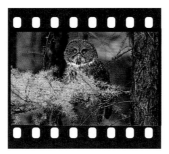

MAXIMUM TELEPHOTO SHARPNESS

When using a telephoto lens, extra care is needed to insure sharpness due to the way the lens magnifies camera shake and vibration.

• Use a sturdy tripod or car-window mount to steady the camera and lens.

• Shoot with the lens aperture wide-open to achieve the fastest shutter speed possible.

• Do not use shutter speeds between 1/8 and 1/30 second. Slower or faster speeds produce less camera vibration. Birds often remain perfectly still allowing sharp exposures between 1/4 and 1/2 second.

• Trip the shutter using a cable or electric release if the bird is inactive; otherwise gently 'squeeze off" exposures.

• If the subject is stationary, lock up the mirror prior to exposure using the mirror lock-up mechanism or the self-timer on minimum delay. (The reflex mirror is the main source of in-camera vibration.)

• Avoid shooting in windy conditions.

OTHER LENSES

Standard and wide-angle focal lengths may be used to depict confiding species like penguins and other sea birds, to portray birds as part of a natural setting, in large flocks, at close range from a blind, or with a remote camera set-up. In these situations, technical considerations follow standard photographic practice.

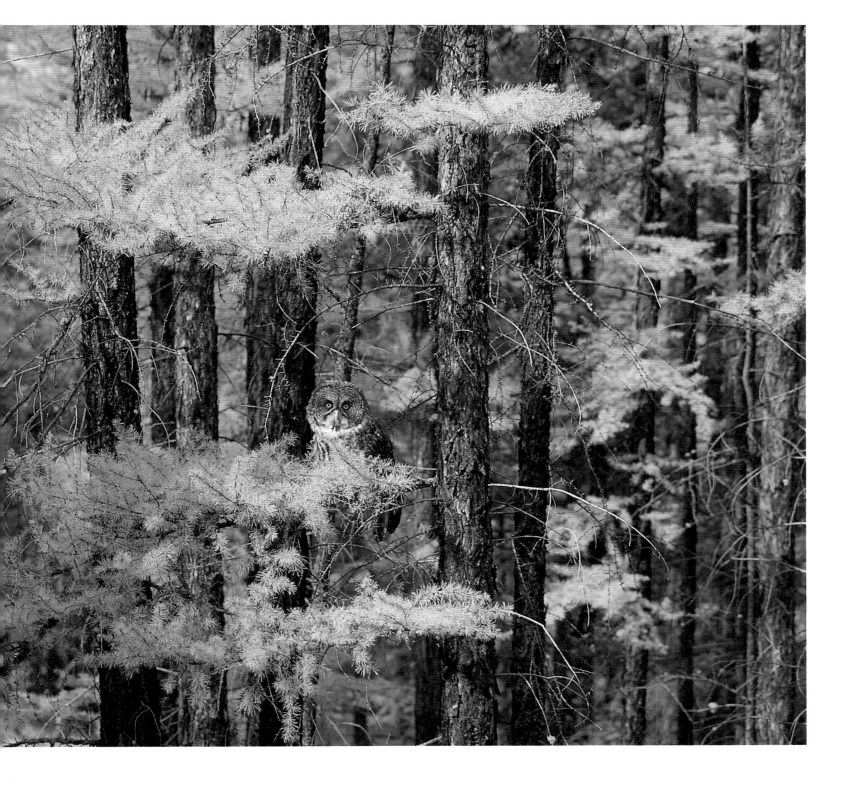

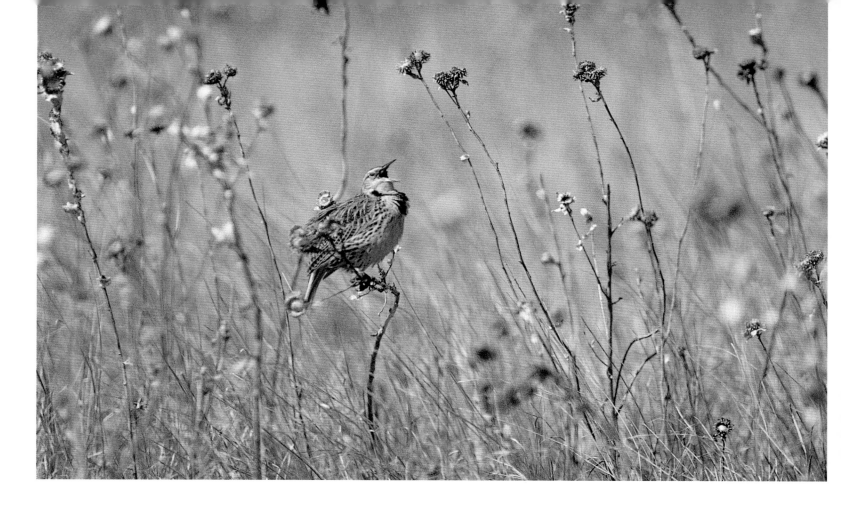

TELE-EXTENDERS

These devices multiply the focal length of any lens while decreasing aperture size. Standard converters are made in 2X and 1.4X powers. A 2X converter used on a 500 mm f/5.6 lens yields a 1000 mm f/11 lens, a combination that is overly powerful and, due to the small aperture, too slow to produce sharp images of active subjects. A 1.4X converter used on the same lens results in a more useful 700 mm f/8 configuration. The length and speed of your prime lens will determine what power of teleconverter is best. Make sure that the converter is made with APO glass elements, otherwise picture quality may be poor.

EXTENSION TUBES

These devices contain no glass elements, fit between the lens and camera body, and allow the prime lens to focus closer than it normally does. They are needed to photograph small species like chickadees and hummingbirds. A 25 mm tube is usually sufficient to bring these species into close focusing range.

CAMERA/LENS SUPPORTS

Telephoto lenses not only magnify the subject, they magnify camera shake and vibration

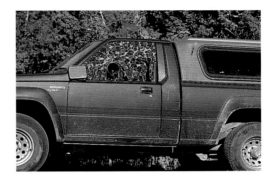

ROADSIDE ATTRACTIONS *PHOTO HOTSPOT*

SHOOTING BIRDS out of a car window is a challenging and exciting photographic method. Due to water run-off, vegetation along roadsides is more lush than that of the surrounding land and attractive as a source of food, cover, and nesting habitat. Songbirds may be photographed displaying from fence posts, trees, and bushes. Soaring hawks commonly hunt roadsides for rodents; kestrels hunt for large insects. Burrowing owls nest in the banks along roadside ditches. Roads through marshy areas offer opportunities to photograph blackbirds and wrens singing from cattails and harriers kiting slowly back and forth in their search for voles. Throughout North America, bird lovers have erected roadside bluebird boxes. During the nesting season, it is not difficult to find one that you can drive up to in cautious stages and, from the front seat of your car, photograph the parents bringing food to the young or chattering from atop the nesting box.

Birds do not normally associate vehicles with humans and so have little fear of them. They become suspicious, however, once the car stops. Use the longest lens that you have and set up the camera on a tripod in the passenger seat which gives ample room and places the camera on the side of the car where shooting will be most convenient. Use camouflage netting to screen your movements inside the car (see photo opposite). Stick to quiet country roads and watch closely for signs of alarm from the bird as you approach. You must be prepared to turn-off the engine and shoot quickly once you are in position. When you spot a possible subject, stop a safe distance away to pre-focus and set exposure so that you can begin shooting as soon as the bird is in the viewfinder. Most birds will fly off shortly after you pull up. Nevertheless, keep trying; patience will soon bring you to a subject that poses co-operatively. Flocks of birds will be easier to get close to than individuals. Usually it is best to drive in a westerly direction which results in a camera position providing either front or sidelighting on the subject. See p. 93 for attracting birds to the vehicle using sound recordings.

The Ultimate Car Window Camera Mount. *Although you might be tempted to buy a commercial window mount, your own tripod may work best. It can be easily set up in the passenger seat (make sure the legs are grounded on the floor), giving you ample room behind the camera to work and allowing you to roll up the window between stops. The camera can be taken off the tripod using a quick-release plate. You can anchor the tripod to the bottom of the seat using elastic (bungee) cords. Total cost is about $3 for the elastic cords. Your movements should be hidden from the birds by draping camouflaged netting in front of the window. Again this is easy—open the car door, drape the netting over the door, then close the door.*

Singing Western Meadowlark, Oklahoma. *It is not easy to find a bird that will allow you to approach closely in the car, especially a solitary bird like this meadowlark. Fortunately, it was singing some distance out in the field, and briefly was undeterred by my presence. Canon T90, 500 mm L Canon, 1.4X tele-extender, Fujichrome Sensia 100, 1/350 second at maximum aperture.*

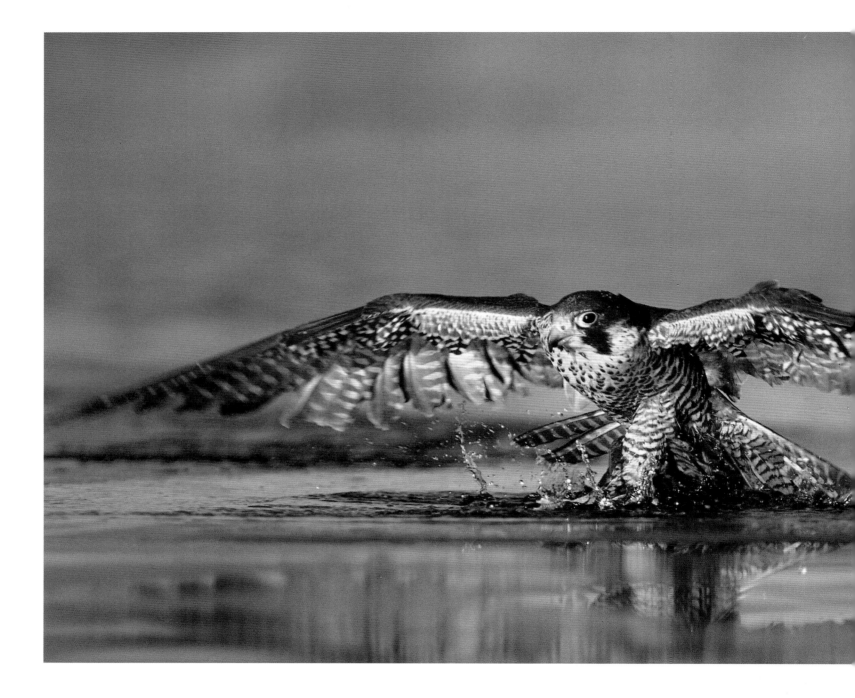

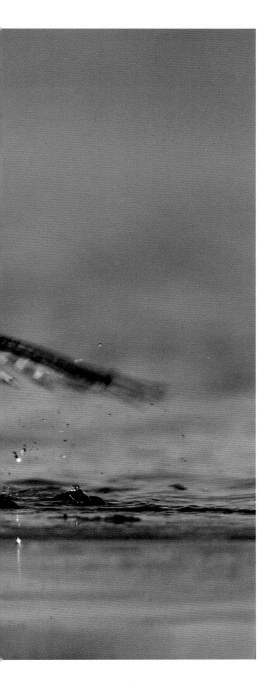

which results in blurred images. For maximum sharpness you must support the camera with a tripod or some other device.

TRIPODS

A tripod suitable for field work should have the following features.
• Tubular aluminum legs for maximum strength and minimum weight.
• With legs extended, the tripod should bring the camera to eye-level without raising the center column.
• The legs should not have center braces. This allows the legs to be spread independently at varying widths, permitting easy set-up on uneven ground or in otherwise awkward situations, such as in trees, cars, boats, and blinds.
• A heavy duty ball head with quick release. This allows fast attachment and easy, precise adjustment of camera/super telephoto lens combinations.

My recommendation for a tripod is the Bogen (Manfrotto in Europe and Canada) 3021 tripod with a Bogen Super Mono-Ball head 3038. This is a sturdy, smooth operating combination that is light in weight, relatively jam-free when used in mud and dirt, and about half the price of comparable professional tripods and heads.

The Bogen tripod's center column is built in two sections. Remove the lower section and throw it away. This allows you to work within a foot of the ground and still provides adequate adjustment

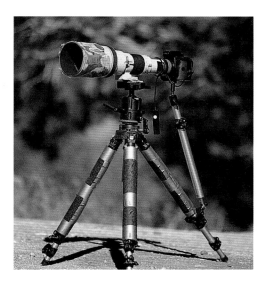

Steadying the Camera. *To attain maximum sharpness, you can't beat the set-up above—a heavy duty ball head (Bogen 3038), an electric hands-off shutter release, the Kirk telephoto lens support, and everything low to the ground out of the wind. Unfortunately, the Kirk lens support takes too long to adjust to use with anything but stationary subjects.*

Peregrine Falcon, Colorado. *When sharpness is important, use all of the light the day offers by keeping the sun behind you to frontlight the bird. This will allow use of the fastest shutter speed possible. Canon T90, 800 mm f/5.6 L Canon, Fujichrome Sensia 100, 1/750 second at f/5.6.*

31

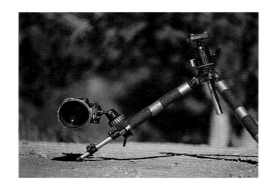

Low-angle Shooting. *By placing the camera low to the ground, you take the viewer into the intimate world of the bird (see photographs at right). It also usually results in displacing the background from the depth of field zone, simplifying the composition and accentuating by contrast the sharpness of the subject. You can usually get to the bird's eye level by adjusting the tripod to its lowest position, providing the center column is short or has been removed altogether. The Bogen Super Clamp (shown above) is a very useful and convenient way to go even lower.*

Clockwise from top left:

Nesting Black Terns, Priddis, Alberta.

Redhead Drake, Moses Lake, Washington.

Brown Pelicans, Bolivar Flats, Texas.

Broad-tailed Hummingbird, New Mexico.

of the camera position at higher levels. For working right at ground level, attach the ball and socket head to the bottom of one tripod leg using the Bogen Super Clamp. No other method I know of is as convenient or stable.

TRIPOD PADDING

You can make your tripod more comfortable to carry and warmer on the hands in cold weather by wrapping the upper section of legs with closed-cell foam pipe insulation. This material is available in any hardware store at little expense and can be fastened to the legs in a jiffy with duct tape.

CAR-WINDOW MOUNTS

A lot of bird photography can be done from the car which makes an excellent blind. The best way to stabilize your camera inside the car is to set up your regular tripod in the passenger seat. A commercial car window mount can also be used. Get one that attaches not only to the window but also has braces that rest on the side or floor of the car. The best ones are sold by Leonard Lee Rue Enterprises and Kirk Enterprises (see the Appendix).

EQUIPMENT BAGS

Often you will have to hike some distance to photograph birds so try to get a bag that can be worn like a backpack, preferably with an internal frame and additional straps that fasten about your hips. The bag should be waterproof (some are not) and hold your longest lens with camera attached. Such a bag will have plenty of room for film, extra lenses, and cameras. If long distance air travel is in your plans, make sure the bag can be classified as carry-on luggage.

BINOCULARS

For the serious bird photographer, binoculars are essential. They are useful for locating and identifying species, assessing terrain over which a stalk may be made, and observing nesting activity. Considering all of the photographic gear that you must carry and keep track of, compact model binoculars of approximately 8X20 power are the most practical size.

CARE OF EQUIPMENT

The greatest hazard to your equipment is moisture. Do not let rain or snow fall on the camera or lens and keep a small towel handy during inclement weather to blot up stray drops. You can purchase custom-made rain jackets to keep your big lens and camera dry while you are shooting (see the Appendix) or you can make your own. I normally refrain from photographing in the rain, but I keep plastic sheeting and tape in my camera bag for temporary protection should an opportunity prove too tempting. When bringing cold equipment inside, slip it into a plastic bag to prevent water condensation.

Dust can cause your equipment to jam once

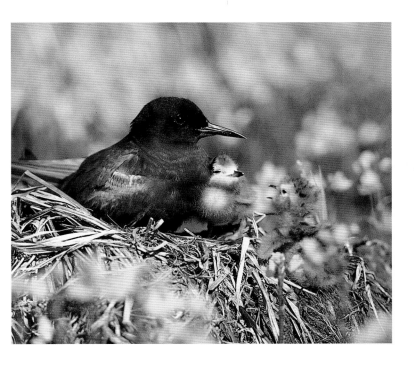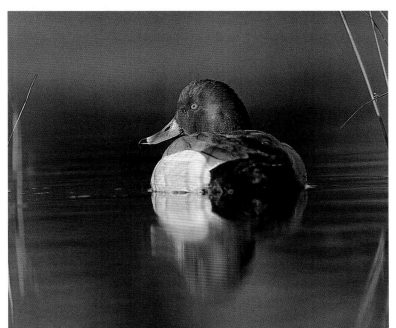
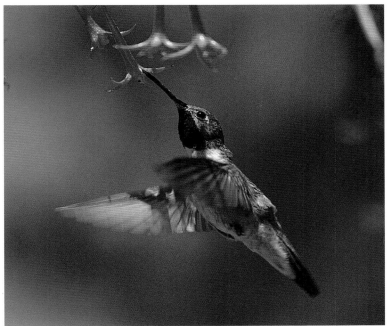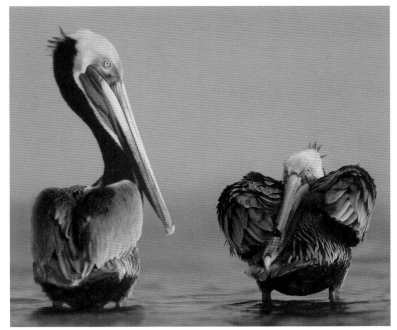

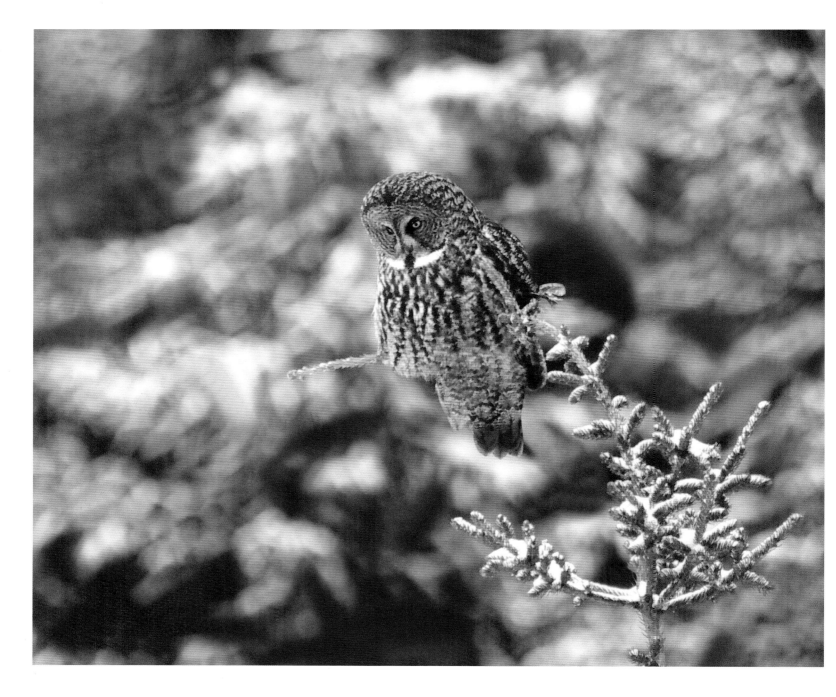

🐦 CHURCHILL / HUDSON BAY *PHOTO HOTSPOT*

THE MOST accessible photography of arctic birds is found in Churchill, Manitoba, a remote town on the shores of Hudson Bay. Situated on the treeline, its quiet groves of stunted spruce open onto permafrost tundra strewn with rocks and cushioned elsewhere with sedges, grasses, and lichens. Many of the birds you may have seen migrating through your own neighborhood, but here on their breeding grounds their behavior and appearance are likely to be different. The tundra is a hotspot for nesting shorebirds. In mid-June, you can photograph whimbrel, lesser golden-plover, least sandpiper, red-necked phalarope, Hud-

sonian godwit in rich breeding plumage, full song, and ritualized display. In addition to shorebirds, the tundra is the breeding site for hoary redpoll, short-eared owl, lapland longspur, northern shrike, willow ptarmigan, and snow bunting. Northern serenades emanate from areas of marsh and muskeg—the gulping thunder of American bitterns, the winnowing sounds of diving snipe, the jangling flight call of lesser yellowlegs, and the haunting yodel of Pacific loons. Where the Churchill River enters the immense expanse of Hudson Bay, you will see arctic terns and parasitic jaegers feeding on the fish stirred up by beluga whales that congregate here. Other waterbirds in evidence among the broken ice-floes include red-breasted merganser, king eider, harlequin duck, and Sabine's gull.

The best time to visit is mid-June. You can fly into Churchill from Winnipeg or you take one of the last great wilderness train rides in North America from Thompson, Manitoba. Churchill has ample motels and restaurants. You can rent a car or pick-up truck from one of the residents, or even hire a local person to take you bird finding. There are only a few miles of roads leading out of town. Much of the area is accessible by foot. You will meet many birdwatchers, naturalists, and field researchers.

Churchill is a frontier town, and you will enjoy visiting the general store, talking to the residents, many of whom are natives, and strolling about the dilapidated buildings. Visit the ruins of Fort Pierce, built by the Hudson Bay Company in the 1700s, and the polar bear jail, which may have an inmate or two even though most bears do not show up around town until early fall.

it works into the camera's interior mechanisms. Be especially careful when driving on dirt roads to keep your equipment well sealed in the camera bag. Sand is even more destructive and unless caution is exercised it is easy for particles to inadvertently get into your equipment when shooting on the beach or sand dunes.

COLD BATTERY OPERATION

At near freezing or colder temperatures, battery power is greatly reduced. To insure uninterrupted shooting, keep a spare set in your pocket and switch the batteries in and out as needed.

Great Gray Owl, British Columbia. This owl was hunting for small rodents after a heavy snowfall. Like most individuals of this species, it was very tame and paid little attention to me as I approached to photograph and watch it dive into the fresh snow for mice which it located by listening for their movements out of sight beneath the snow. Canon F1, 500 mm f/4.5 L Canon, Fujichrome 50, 1/15 second at f/4.5.

Capturing the Beauty of Natural Light

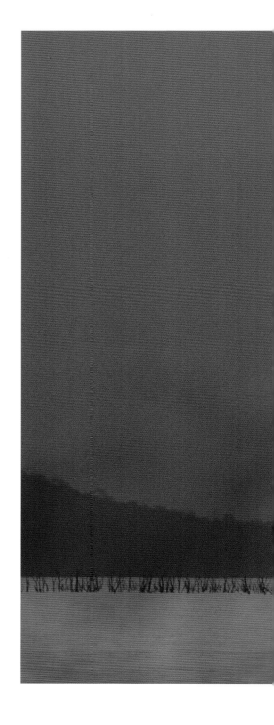

NATURAL LIGHT CAN INFUSE your images with beauty, drama, immediacy, intimacy, even truth, and sometimes magic. Although you may not always be sure where you will find light with such special properties, you can be sure of when you will find it—*very early or very late in the day when the sun is near the horizon*. To look for it at any other time is usually futile.

Fortunately, the majority of birds are at their peak of activity at this time. You will see the most birds early in the morning when they are engaged in interesting behavior—feeding, courting, singing, and flying. The late afternoon ranks a close second, a time which may be more suitable to your own schedule of work and play.

Light is the photographer's paint. To spread it most effectively on the canvas, you must understand and recognize its visual properties: intensity, quality, direction, and color.

LIGHT INTENSITY AND EXPOSURE

Although the intensity of the sun's light changes throughout the day, the intensity of light needed to produce a proper exposure on the film in your camera is constant.

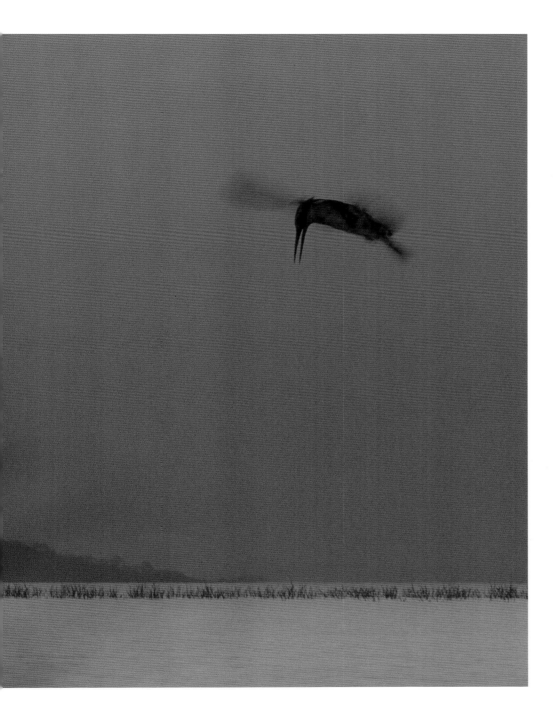

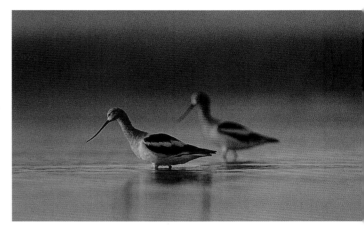

American Avocets, Salton Sea, California. I try to restrict my photography to a few hours before sunset (when this picture was taken) and a few hours after sunrise when the light is warm, soft, and can be applied to the subject from the front, side, or back depending on the camera position you choose. At mid-day, you have basically one choice—toplighting. It is important to capture the birds when they are looking into the light as this pair of avocets is doing. Canon F1, 500 mm f/4.5 L Canon, Fujichrome 100, 1/250 second at f/4.5.

Pied Kingfisher, Lake Kariba, Zimbabwe. When making silhouetted compositions which include the sun, conditions must provide enough atmospheric filtration to reduce the brilliance of the sun to the same range (within two to three stops) of the surrounding sky. Set exposure using a spot metering pattern on the portion of the scene whose color and tone is most important. Canon T90, 100-300 mm f/5.6 L Canon at about 150 mm, Fujichrome Sensia 100, 1/125 second at f/8.

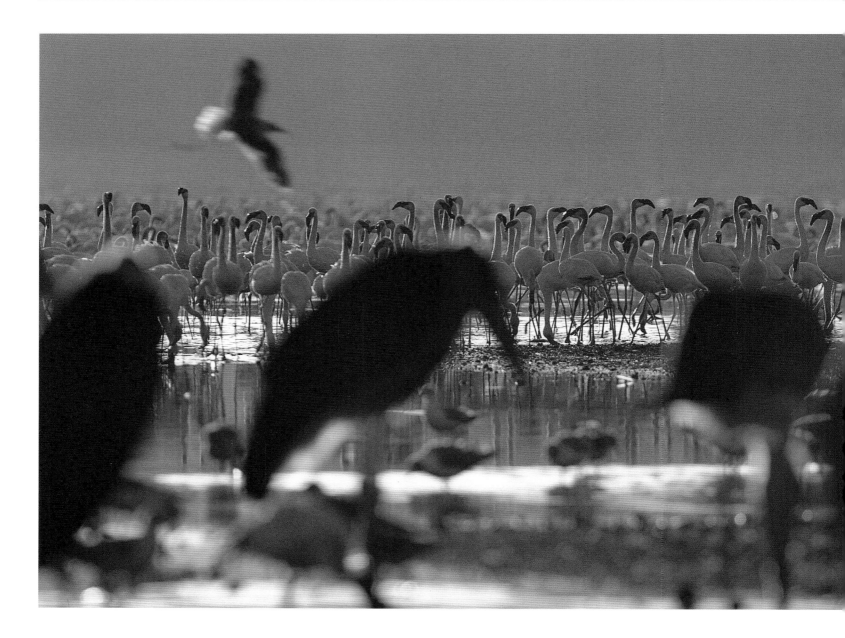

The camera has two mechanisms that control exposure: a variable-speed shutter determines the duration of the exposure and the lens' variable aperture determines its intensity. Shutter speeds and apertures are reciprocal and equally calibrated so that if you increase one, it is easy to decrease the other by the same amount to maintain the desired exposure. The aperture and shutter settings, referred to as 'stops', are determined by the camera's light meter and controlled automatically in auto-exposure cameras.

SETTING EXPOSURE FOR BIRDS

Exposure technique in bird photography is usually rather simple—set the camera on automatic exposure. This allows you to give full attention to the demanding task of framing and focusing on the often small, fast moving, unpredictable avian subjects.

If you have a choice, set the metering pattern to either center-weighted or evaluative. If possible, take extra 'insurance' pictures over and under the camera's automatic exposure settings (called bracketing) of important or high contrast shooting sequences. This is done using the camera's exposure compensation dial. Although automatic exposure operation is not always perfect, it enables you to achieve the highest percentage of properly exposed and accurately focused images.

OVER-RIDING AUTOMATIC EXPOSURE

The camera is unable to make automatic

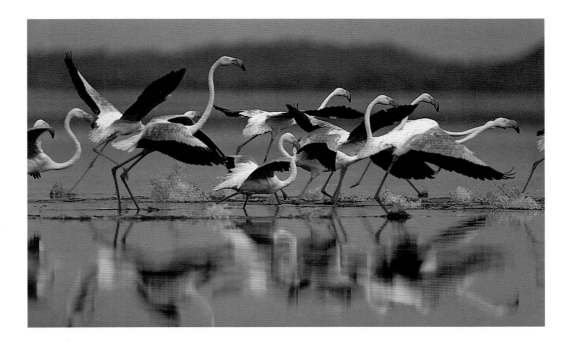

Marabou Storks and Lesser Flamingoes, Lake Nakuru, Kenya. *Backlighting delicately outlines the graceful heads and necks of the flamingoes and simultaneously throws into silhouette the ominous forms of the marabou storks—frequent predators of the flamingoes. In backlighting situations, it is important to use a lens hood to prevent sunlight from striking the front lens element directly. Canon T90, 500 mm f/4.5 L Canon, Fujichrome 100, 1/250 second at f4.5.*

Greater Flamingoes, Lake Bogoria, Kenya. *Even illumination from a lightly overcast sky produces rich color in this scene. I set up the camera along the shoreline and then waited until some boys walked past, putting the birds to flight. The motor drive allowed about five frames before the birds moved out of range. Exposure was based on an average reading of the scene. Canon T90, 500 mm f/4.5 L Canon, Fujichrome 100, 1/500 second at f4.5.*

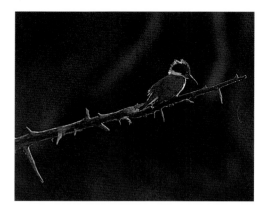

Belted Kingfisher, British Columbia. *I under-exposed this scene by 1.5 stops in order to retain the highlight detail about the periphery of the bird and its perch. It resulted in a dramatic contrast between the main subject and the background.*

Heermann's Gulls, Mexico. *Even though this scene is high in contrast, the light areas and dark areas balance one another, so I used a metering pattern which took an average reading of the entire scene.*

exposures accurately of scenes which are either unusually dark (raven roosting in a rain forest) or light (snowy owl perched on an ice hummock). The light meter reads every scene as if it were of average brightness (18% gray). It will over-expose the raven and under-expose the snowy owl. To retain accurate color and brilliance, you must manually over-ride the meter. Use the exposure compensation dial to *decrease* exposure one stop for the raven and *increase* it one stop for the owl. Bracket exposures as it is difficult to predict accurately how much compensation is required.

CREATIVE CHOICES

Your choice of aperture and shutter speed should be the result of artistic intent. Usually, you will strive to attain the sharpest, most detailed image of the bird(s) as possible. This necessitates the use of a fast shutter speed to minimize both camera shake and the movements of the bird. Consequently, you should set the camera's automatic exposure program to aperture-priority and set the aperture at maximum. This will automatically make use of the fastest shutter speed that the lighting conditions and film type permit. Ideally the shutter speed (displayed in the viewfinder) should be twice the inverse of the lens focal length (1/1000 second for a 500 mm lens). If there is enough light to permit speeds faster than this, use the extra illumination to close down the aperture which will increase the depth-of-field (zone of sharp focus) and facilitate focusing.

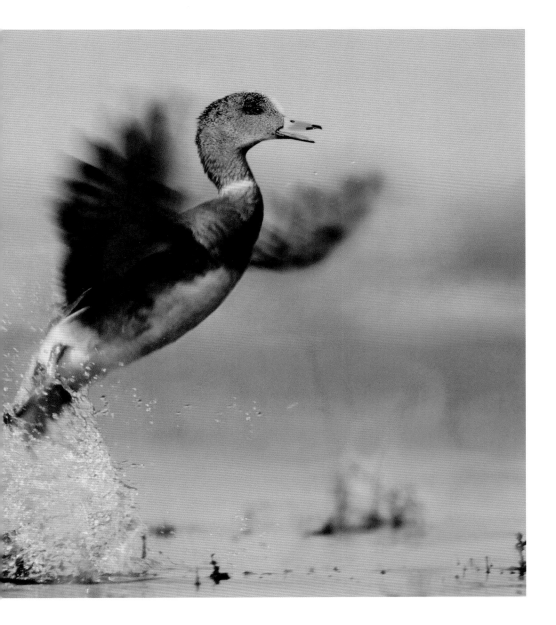

American Widgeon, Alberta. *In this image, my main concern was to freeze the action of the subject. Consequently I set the automatic exposure program for aperture priority (AV) and selected the maximum aperture. This procedure automatically results in the highest shutter speed possible. Even so, in this instance the head of the duck was blurred. I transplanted a sharp head taken from another frame made only a few seconds before take-off using digital imaging techniques on my desktop computer system. I approached the bird in a mobile blind. Canon T90, 500 mm f/4.5 L Canon, Kodachrome 64, 1/500 at f/4.5.*

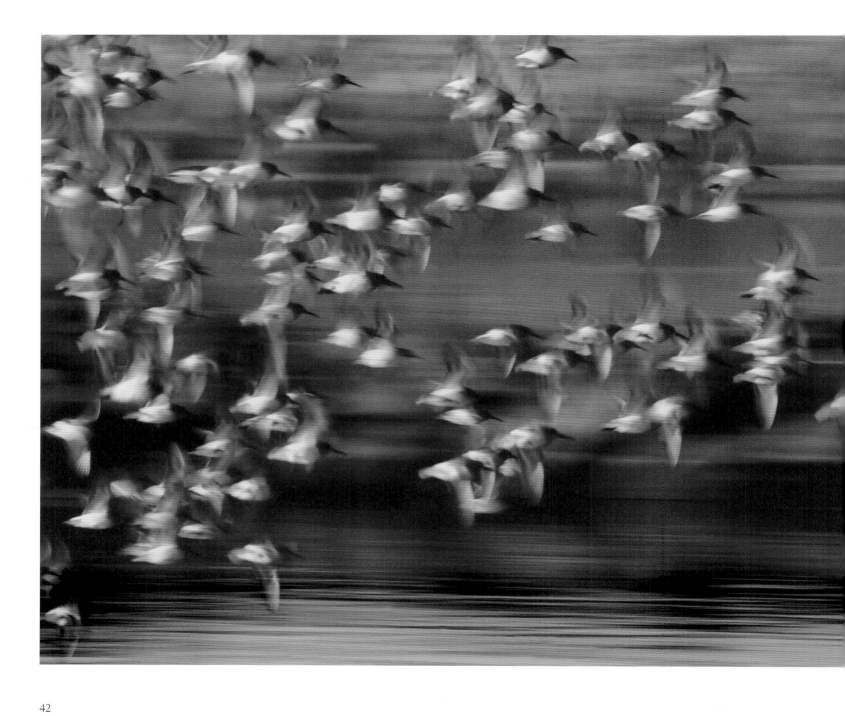

If you are making blurred-motion pictures, then set the program to shutter priority and select the desired shutter speed—usually 1/30 second, but this varies with the bird species, its activity, and the degree of blurring desired.

LIGHT QUALITY AND CONTRAST

In photographic terms 'hard light' produces distinct sharp-edged shadows. Except when striving for a special effect, it is seldom desired because the difference in brightness between highlight and shadow areas is too great for the film to record; one or the other will be improperly exposed. At its worst, it emanates from a high-noon sun on a cloudless day, the time when all good photographers are taking a nap.

On the other hand 'soft light' illuminates the subject evenly, producing shadows with soft, or even indiscernible, edges. At its extreme, which is not necessarily desirable, it occurs on evenly overcast days. Although this light will produce maximum color saturation throughout the scene,

Western Sandpipers, Boundary Bay, British Columbia. For this picture, the design priority was to blur the birds and background, which required a shutter speed of 1/30 second. Consequently, I used the shutter priority automatic exposure program (TV) and set the shutter speed appropriately. The camera then selected whatever aperture was necessary for correct exposure. I panned as the flock passed, keeping the camera action as smooth and level as possible.

🦩 BOSQUE DEL APACHE *PHOTO HOTSPOT*

THIS NATIONAL wildlife refuge, located in central New Mexico is renowned for the huge congregations of greater sandhill cranes and snow geese that begin arriving each October to spend the winter. Flocks numbering thousands fill the skies each morning and afternoon as the birds move between their nightly resting areas in the marshes to the grain fields where they feed during the day. Rare whooping cranes can often be spotted among the sandhill cranes. There are also tens of thousands of ducks of more than a dozen species and large numbers of shorebirds that pass through the refuge during migration. Avocets and black-necked stilts nest on small islands of vegetation in the spring.

During winter, bald and golden eagles and red-tailed and ferruginous hawks perch in the cottonwoods watching the waterfowl with hungry eyes. Wild turkeys, Gambel's quails, and roadrunners are common sights, especially in the early morning.

There is 15 mile auto-tour route, and you can pull over to take pictures just about anywhere, either from the car or along one of the many hiking trails. In the dry climate of New Mexico, beautiful sunsets are to be expected. This together with the imposing backdrop of the Magdalena Mountains make Bosque del Apache an excellent location for photographing impressive landscapes overlain with equally impressive numbers of birds. The shallow ponds scattered through the refuge provide good opportunities for dramatic reflections of both sunrise and sunset, as well as large flocks of cranes and geese that are found everywhere. Although the refuge is rich in bird life the year round, November through February is the only time to be sure of photographing the large flocks of migrants. Parts of the refuge are restricted due to hunting in November. You can set up a blind with a special permit issued by the refuge manager. Albuquerque is the closest point of arrival if travelling by air. The town of Socorro, just north of the refuge, has many motels and restaurants. You should make reservations if visiting during the Festival of the Cranes, held in the middle of November.

it is undramatic and does not produce three dimensional modeling of the bird or the landscape.

When the sun is near the horizon, its light is subjected to maximum filtration by the earth's atmosphere. Its rays are diffused and produce shadows that are less harsh than those of midday. Early morning and late afternoon light are the cornerstones of dramatic lighting. Add a few clouds to bounce some extra light and color from a rising or setting sun into the shadows and conditions become ideal.

LIGHT COLOR AND MOOD

Although we generally think of light as neutral in color, it acquires tint when it is reflected from colored surfaces—water, rocks, foliage, or any elements of the landscape that are large or close to the subject. Sometimes this is desirable, as when shooting a cardinal whose rich red plumage gains intensity by light bouncing from fall foliage. However, in the same setting, a blue jay's feathers would lose some of their color drama. More useful to the photographer is the color light gains from atmospheric filtration, especially around sunset, when the sky is filled with particles of dust stirred by a day of wind and moving vehicles. The yellow and orange tones which result impart a warm, inviting mood to the picture.

LIGHTING ANGLES

The angle at which light strikes the subject has a significant impact on the rendering of color,

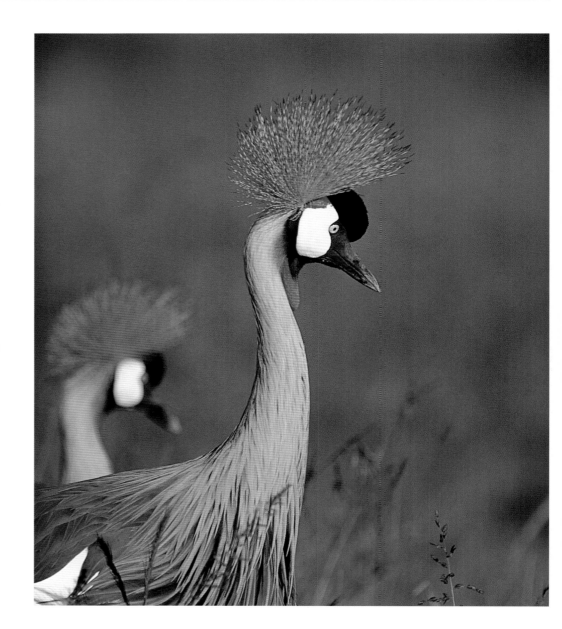

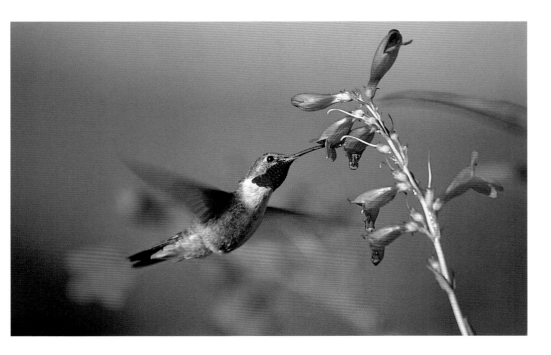

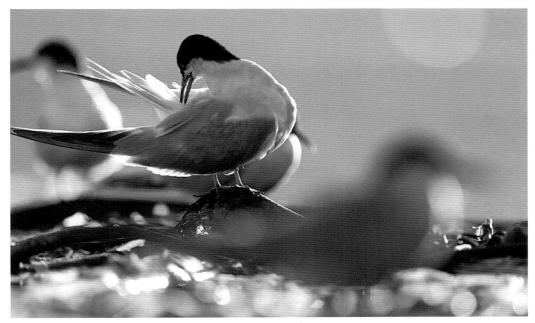

Crowned Cranes, Nairobi National Park, Kenya. *Shooting from a jeep, I kept the camera as low as possible to include a smooth wash of out-of-focus vegetation in the background. I followed the birds as they moved about looking for prey in the deep grass. Late afternoon frontlighting produced low contrast with strong color saturation. Canon T90, 500 mm f/4.5 L Canon, Fujichrome Velvia, 1/250 second at f/4.5.*

Broad-tailed Hummingbird, New Mexico. *Frontlighting produced good color saturation in this image and its high intensity permitted a shutter speed fast enough to arrest most of the motion of this hummingbird. To attract the birds, I used an eye-dropper to fill these flower tubes with hummingbird nectar. I took care to make sure the background (sky and out-of-focus blooms) supported the center of interest. Canon A2, 500 mm f/4.5 L Canon, 25 mm extension tube, Fujichrome Sensia 100, 1/350 second at f/4.5.*

Common Terns, Vancouver Island. *In addition to the pose of the bird, the dramatic effects of this scene are due to backlighting and the reflective surface of the shoreline which provided illumination in the shadow areas, resulting in more detail and color. The terns were photographed from a blind erected on a gravel bar were birds gathered at low tide. Canon F1, 500 mm f/4.5 L Canon, Kodachrome 64, 1/250 second at f/4.5.*

Red-tailed Hawk, Montana. *Sidelighting is effective in portraying the texture of the subject. When using a high contrast film, such as Fujichrome Velvia, the shaded portion of the subject will lose detail to under-exposure unless it receives light reflected from some other area of the scene. The yellow grasses provided the necessary fill light for this hawk which I photographed from the roadside as it plucked its kill. Canon A2, 500 mm f4.5 L Canon, 1.4X teleconverter, Fujichrome Sensia 100, 1/125 second at maximum aperture.*

Pied-billed Grebe, Stinking Lake, New Mexico. *When using backlighting, try to take a camera position that includes dark background elements. Usually any part of the landscape that is in shadow works to dramatize the illumination of translucent elements—in this case feathers and spraying water. Canon A2E, 500 mm f/4.5 L Canon, Fujichrome Velvia, 1/250 second at f/4.5.*

texture, depth, and reality of the image. The lighting angle is determined by camera position, which must be established in the absence of the bird, and usually cannot be changed unless shooting from a mobile blind or working with subjects that are unafraid of humans.

SIDELIGHT

This is usually your surest way of achieving dramatic lighting. Sidelighting is the best way to show the texture and form of a subject. In the northern hemisphere, set up the camera to the south of where you expect the bird(s) to appear and you will experience strong sidelighting during both the morning and afternoon shooting periods.

FRONTLIGHT

Probably the first photographic advice you ever received was to shoot with the sun at your back. The front lighting which results flattens the scene and produces good color saturation which will have a warm cast if you are shooting early or late in the day. Its biggest advantage is brightness which permits the use of the fastest shutter speed possible, producing maximum stop-action affects—great for recording birds in flight or engaged in other high energy behavior.

BACKLIGHT

When the sun is in front of the camera, a halo appears about the bird as the feathers on its

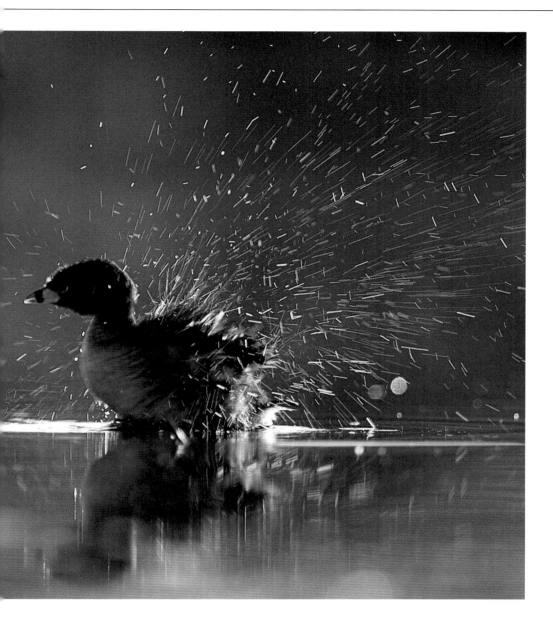

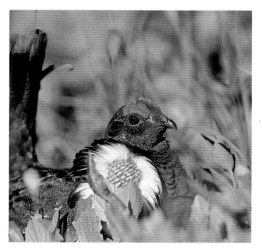

Blue Grouse, Mount Rainier, Washington. *The white ruff of feathers about the grouse's neck works as a miniature reflector to even out the high contrast illumination of midday frontlighting. Blue grouse are common in western alpine meadows during the wildflower season when they can be easily approached. Canon T90, 500 mm f4.5 L Canon, 25 mm extension tube, Fujichrome Velvia, 1/500 second at f/4.5.*

Stretching Mallard, Vancouver Island. *In the Pacific Northwest, the rainy winter season offers a warm refuge for many migrants, but little variation from overcast lighting conditions. When it is overcast, I shoot during midday when it is brightest and shutter speeds of 1/125 to 1/60 second are possible using ISO 100 film. The soft lighting recorded the subtle color variations of this mallard's plumage. I made the mirror image from the single frame above using Photoshop image editing software on my desktop computer.*

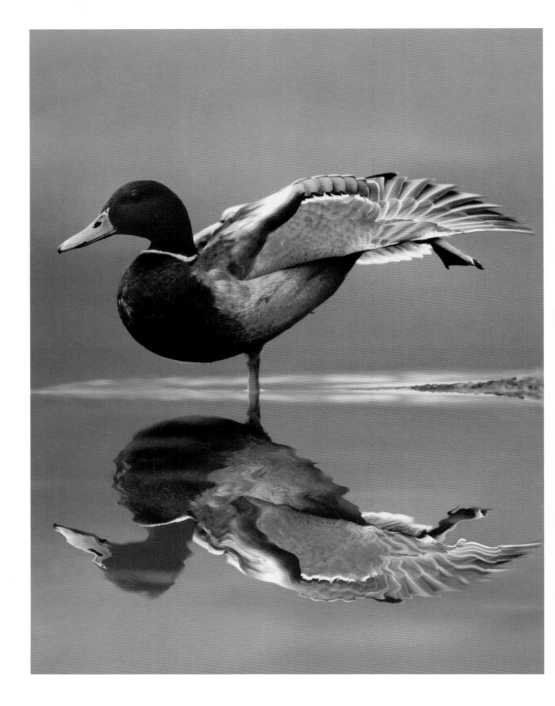

periphery are illuminated by backlight. The effect is dramatic and often surreal. It may be accentuated by positioning the camera so that the subject is recorded against a dark background. Any part of the landscape which is in shade will be satisfactory. Automated cameras will usually achieve the desired exposure provided the sun itself does not appear in the frame and an efficient lens hood is used. You should take a few extra pictures with exposure reduced one or two stops to insure proper exposure of highlighted elements and reduction of distracting detail in the background.

OVERCAST LIGHT

Illumination from an overcast sky produces strong color saturation and high detail in all areas of the picture. Unlike the warm color bias of frontlighting, its color is neutral. Action photography is handicapped by its low intensity which keeps exposures in the 1/60 to 1/125 second range at f/4—5.6 with average speed films (ISO 100). Avoid compositions that include any portion of the sky for it will be recorded as a distracting area of white which will rob the main subject of its visual appeal. If the sky is overcast, shooting can be postponed to the middle of the day when the light will be strongest, although bird activity will be limited.

FILMS

Birds are colorful subjects, living in colorful environments. Like us, they see and communicate

🐦 TEXAS COAST *PHOTO HOTSPOT*

THIS COASTAL habitat offers a wide range of photographic opportunities. Much of the shoreline is comprised of marshes, shallow lagoons, sandbars, and mangrove swamps that attract a variety of wading birds and over-wintering grebes, loons, waterfowl, and shorebirds. Of particular renown is Aransas National Wildlife Refuge where endangered whooping cranes pass the winter. The easiest way to photograph these large waders is to board one of the birding tour boats, which leave several times daily from the town of Rockport. Birds migrating to and from South and Central America

pass along the coast during fall and spring. Nowhere is there a better opportunity to photograph migrating songbirds in spring plumage than in the town of High Island, located a few miles inland north of Galveston. This hump in an otherwise table-flat landscape is the only place for miles where there are trees. Warblers, vireos, thrushes, grosbeaks, buntings, and orioles, exhausted by their flight across the Gulf of Mexico, home in on this solitary refuge. The best time to visit is during stormy weather in mid-April, when the oak and hackberry trees are alive with birds. While you are in the vicinity, be sure to visit Bolivar Flats at low tide to see perhaps the most varied aggregation of shorebirds on the continent (including avocets in flocks of a thousand) and hundreds of white and brown pelicans loafing on the sandbars. During the winter, you can photograph as many as 30 shorebird species. Another attraction is in Texas' deep south, along the Rio Grande River. Here, subtropical vegetation draws rarities from Mexico, including the least grebe, black-bellied whistling tree duck, chachalaca, tropical kingbird, kiskadee flycatcher, and the hook-billed kite. Don't miss the tiny but spectacular Santa Ana National Wildlife Refuge, one of the best places to experience this habitat. The Attwater Prairie Chicken Refuge west of Houston is home to this endangered sub-species. They perform their courtship dances during March and April. The Texas Hill Country west of Austin and San Antonio is ablaze with wildflowers during April, although you will see plenty of beautiful patches elsewhere. The most central access is from Houston. Abundant facilities are available along the length of the coast. March and April are the best months to photograph resident, migrant, and wintering birds and wildflowers.

using color. Both logic and aesthetic sense suggest the use of color film.

Because the bird photographer works with small, active subjects requiring brief exposures at periods of the day when light intensity is low, a 'fast' film (one highly sensitive to light) is desirable. Unfortunately, the faster the film, the more limited is its reproduction of fine detail and saturated color.

A film with ISO speed 100 is a good compromise between strong color, good detail, and adequate light sensitivity. There are many types of film of this speed produced by Kodak, Fuji, Agfa, and other companies. The better ones come from Fuji and Kodak, with no significant difference between them. Each of these companies offers film in professional and standard varieties, the difference is that extra care is taken to insure precise color balance and sensitivity of the professional films, a factor normally of little concern to bird photographers. Professional films are usually twice the price of their amateur counterparts.

FUJICHROME VELVIA

This film deserves special mention because of its exceptional rendering of rich color and fine detail. It is preferred by many professional nature photographers. It is rated at only 50 ISO and under the same lighting conditions it will require an exposure that is twice as long as the ISO 100 films. If there is enough light, however, it is worth the sacrifice in shutter speed. It is high in contrast,

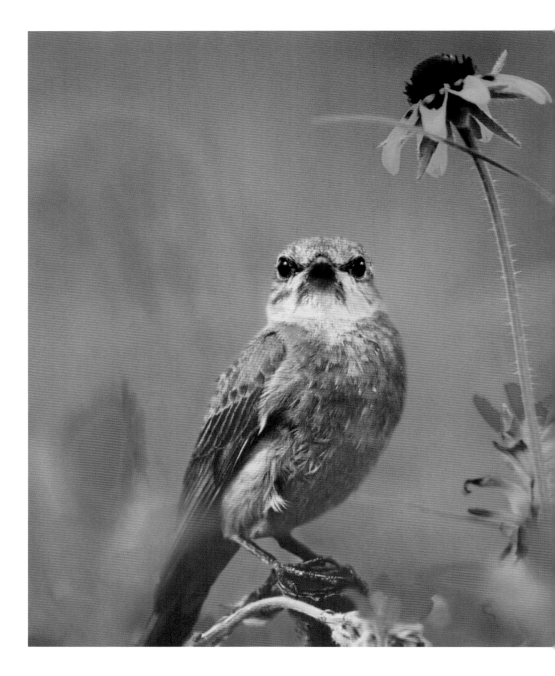

Eastern Bluebird, Ontario. This bluebird was photographed in Ontario in 1987 on Fujichrome 50 from the blind shown at left. I set up a perch near the nest box which both parents landed on for a few seconds each time they returned to feed the young. I embellished the perch with some vetches that were growing nearby but the image never matched my memory of how beautiful a bluebird looks when it is hunting for insects in a wildflower meadow. A few years later, I photographed this wildflower scene in Texas on Fujichrome Velvia. The eastern bluebird also makes its home in Texas so I decided to marry the two images using digital imaging techniques and Photoshop software on my desktop computer.

however, and performs poorly under sunny mid-day conditions.

PRINTS OR TRANSPARENCIES

If you have aspirations (why not?) of seeking publication of your bird photographs in calendars, magazines, etc., shoot transparencies. They yield the best reproduction quality and are preferred by editors because they are easy to review, ship, and store. Slides can be projected for your friends and neighbors and the best ones can be chosen for enlargement into beautiful prints. Conversely, print film cannot be converted easily into high quality transparencies.

STORING TRANSPARENCIES

Keep your transparencies in slide-filing sheets which are a little bigger than letter size, hold 20 slides, and fit into a three-ring binder or standard file folder. Archival quality sheets are chemically stabile and prevent the color shifts and fading which occur with non-archival types. Store slides in a dark, cool place such as a filing cabinet. Valuable images should also be placed inside individual plastic sleeves, called 'Kimacs' (see the Appendix) to prevent damage when handled.

FILTERS

Filters are used little in bird photography primarily because they reduce the amount of light available for exposure, a commodity nearly always in short supply. A warming filter may be used to

🦆 YOUR OWN BACKYARD *PHOTO HOTSPOT*

GOOD BIRD photography is as far away as the back door or the kitchen window. If you live in a rural or suburban area with a small lot, it is possible to convert your property into an oasis for birds. You will be creating photographic opportunities for yourself and replacing needed habitat for wildlife.

Nearly immediate results will come from setting up a bird feeder. Anything that holds seeds and allows the birds easy access will work. If possible, hang the feeder in a small deciduous tree, which provide perches where birds will land on their way to the feeder, making them easy to photograph. The best mixtures of wild bird seed (available in supermarkets, pet stores, and feed stores) have lots of sunflower seeds and millet, and little corn. Suet is especially attractive to insect-eating species. It is easily procured by pouring melted bacon fat directly into the feeder. In cold weather, it will harden quickly and stay put. You can keep your feeders stocked year-round, but they will be most popular from late fall until mid-spring when wild food stocks ebb. A feeder may induce some species to forego migration, so be sure to keep it replenished once cold weather arrives. Feeders will bring in most of the year-round residents—sparrows, thrushes, woodpeckers, jays, grosbeaks, doves, pigeons, blackbirds, grackles, starlings, quail, pheasants, and others. Kestrels, merlins, and sharp-shinned and Cooper's hawks will arrive as they become aware of the abundant prey. There is always a chance that a rare species will appear, especially during spring and fall migration.

You can create a natural refuge for wildlife in your backyard by planting trees, shrubs, and wildflowers that offer food, shelter, and reproductive habitat. The best plants offer all three. Hummingbirds (and butterflies) will frequent flower patches in summer, waxwings and jays will pluck cherries in fall, finches and grosbeaks will take shelter in cedar hedges during winter storms, and robins will hide their nests in pine trees in spring. There are many books that describe how to operate a bird feeder and how to establish a backyard wildlife sanctuary. Be sure to refer to one that is specifically written for your area. Excellent information is available from The National Wildlife Federation. In addition to birds, you will attract squirrels, chipmunks, skunks, raccoons, deer, mice, fox, and other animals.

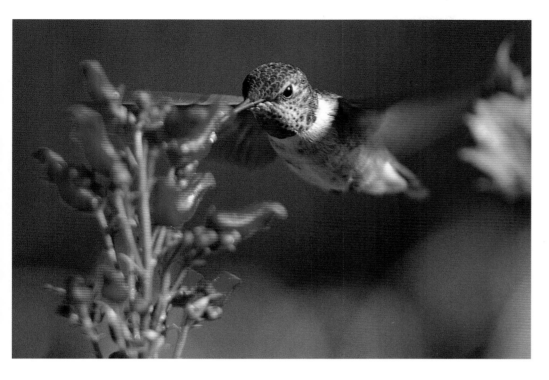

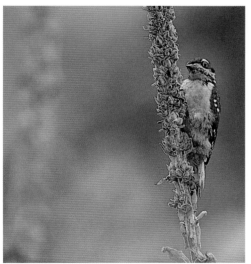

Broad-tailed Hummingbird at Desert Figwort. *Hummingbirds are perhaps the most fun of all species to photograph in the backyard. They can be photographed in comfortable weather when many species are engaged in entertaining activities. They are readily attracted to any tubular flowers. I simply replaced my hummingbird feeder, which the birds visited regularly, with these potted flowers to attain a natural setting in early morning light. Canon A2, 500 mm f/4.5 L Canon, 25 mm extension tube, Fujichrome Sensia 100, 1/250 second at f/4.5*

American Robin with Mountain Ash Berry. *This bird was photographed from my bedroom window as it came each autumn afternoon to feed on berries. The side of the house, which was painted white, reflected soft light onto the bird, reducing the hard light of early afternoon. Canon T90, 500 mm f/4.5 L Canon, 25 mm extension tube, Kodachrome 64, 1/250 second at f/4.5.*

Downy Woodpecker on Mullein Fruit. *Even weeds are beautiful, especially when they attract a hungry woodpecker. Like most small birds, the downy has little fear of humans and I photographed it after a slow, cautious, low approach. Canon T90, 500 mm f/4.5 L Canon, 25 mm extension tube, Fujichrome Velvia, 1/125 second at f/4.5.*

Pelicans and Hippo, Lake Nakuru, Kenya. *This is mostly a landscape image that includes birds as a key element. I used a warming filter to enhance the color of the setting sun and a Cokin adjustable graduated neutral density filter to darken the upper background region that resulted in a spot-lit effect on the important foreground elements. Canon T90, 80-200 mm f4 Canon at approximately 200 mm, Fujichrome 50, 1/15 second at f4.*

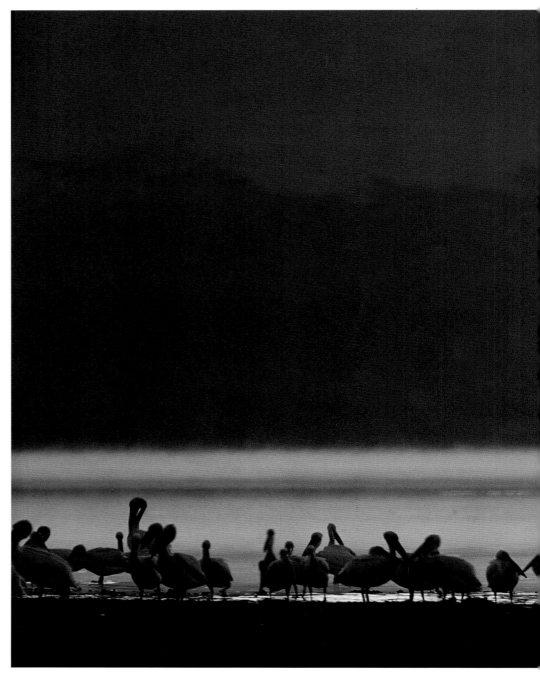

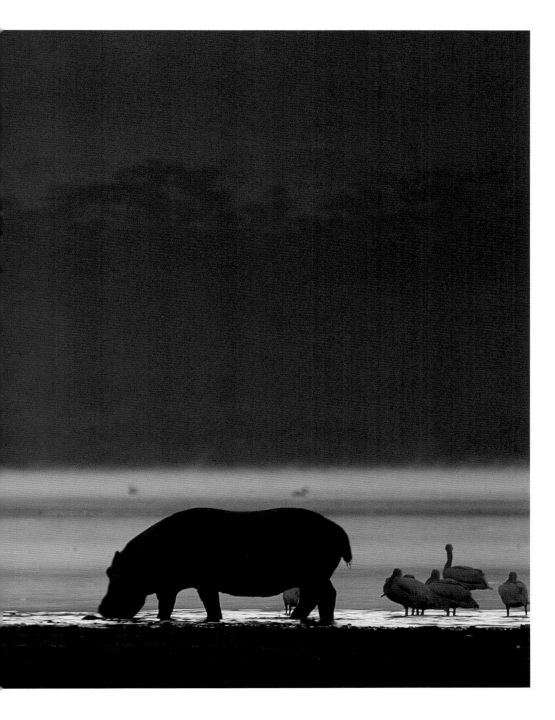

emphasize warm color tones, particularly in images taken near sunrise or sunset when its effect appears most natural. Birds are often photographed as elements of the larger landscape using shorter, faster lenses that do not impose the exposure constraints normally associated with super telephoto lenses and fast moving subjects. In such circumstances, any filters appropriate to landscape photography are of value. A polarizing filter is most useful; it will darken the blue sky, reduce reflections from water surfaces, and increase color saturation in both the bird and vegetation. Its use requires an exposure increase of one to two stops.

Picture Design
From Field to Digital Studio

PICTURE COMPOSITION BEGINS long before you trip the shutter, when you are thinking about the species you would like to photograph, about the behavior, the light, the color, the beauty of a natural moment you wish to portray, about the research and many other preparations you must complete before the simple instant of film exposure is possible. With the development of desktop computer imaging and editing equipment, the composition process may continue long after the film is developed. Whether your pictures are brought back from the field as finished works or compiled and edited afterward in the digital darkroom, the design considerations are the same. Effective picture composition is essential to making images that will inspire and entertain people with the beauty of avian life.

VISUAL DOMINANCE

The graphic elements of the image, the lines, shapes, colors, and textures, occupy a visual hierarchy. When you peer into the viewfinder, you are usually confronted with grasses, leaves, branches, perhaps a splotch of sky or water, and hopefully a bird

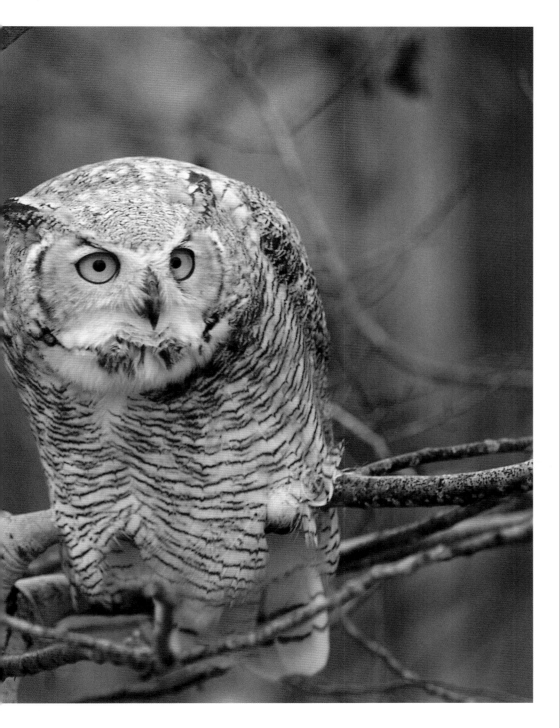

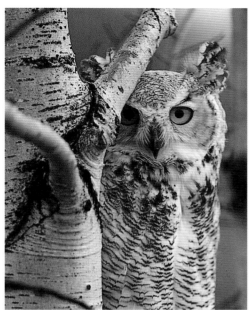

Great-horned Owl, Alberta. *The most significant design decisions regard magnification and camera angle, both of which result from where you place the camera. As I approached this owl, my eyes were not only on the bird to judge its reaction, but also on the shifting arrangement of aspen trunks. As the bird itself is likely to change position, turn its head, or scratch at its plumage, I usually determine camera angle by what will appear in the foreground and background of the image. Once this is established, I time the exposure to capture a dramatic pose of the bird itself. Canon A2, 500 mm f/4.5 L Canon, Ektachrome Lumiere X, 1/125 second at f/4.5.*

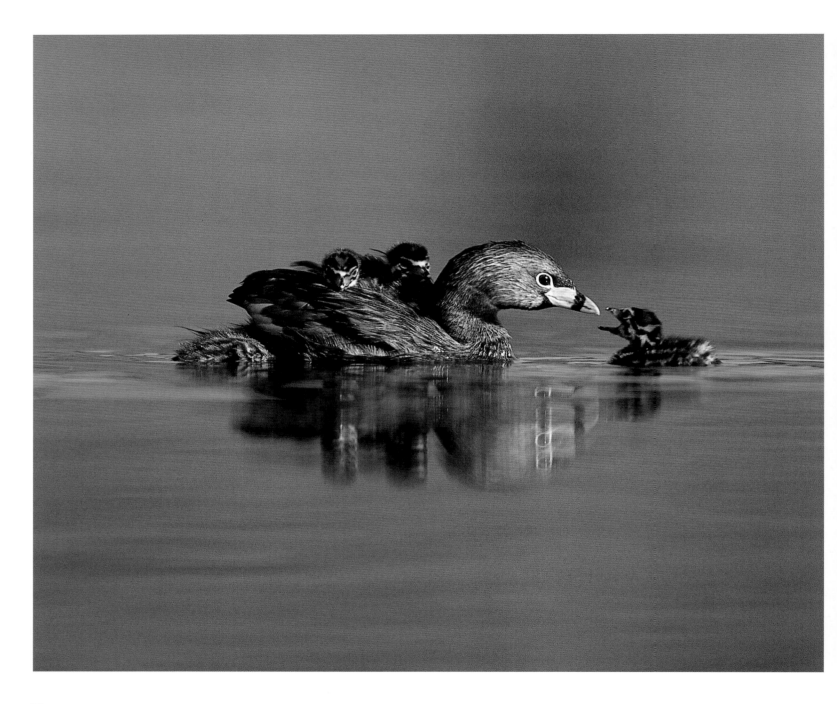

or two. Some features of the scene are brightly lit while others are in shadow; some are in focus, others are only blurs; colors may span the visual spectrum. Each of these features projects a certain attraction to the human eye, an effect which is the same to people all over the planet. Human visual sense tells us, for example, that red is more exciting than brown, that jagged lines draw more attention than curved ones, that rough is more interesting than smooth, and that light is more attractive than dark. The photographer uses these relationships as the basis of the design.

The real world of nature does not present her graphic elements so obviously as the above examples suggest. More often you must compare a green, jagged line with a smooth, turquoise shape. Expressed in literal terms, such evaluations seem difficult, but the eye makes the assessments intuitively and quickly.

ELEMENTS OF DESIGN

If you consider the features of a scene not as beaks, raised wings, flowers, or setting suns but as graphic elements—shapes, lines, textures, and colors, an objective analysis of the composition results. The bird in the viewfinder is not an endangered flycatcher but a narrow, yellow-green shape; twigs are brown, jagged lines; sparkling water droplets are white circles. With this awareness, the arrangement of graphic elements can proceed with logical purpose.

Shapes are the main ingredients of most

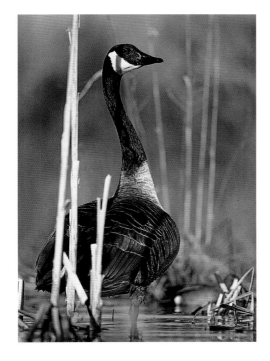

Pied-billed Grebes, New Mexico. *This family was photographed near their nest site. I knelt in the water inside a mobile hoop blind (see Part IV), keeping the camera low to the surface of the pond to throw the background out of the depth-of-field zone. I made many exposures before the mother finally oriented her body at right angles to the camera, bringing at once all of the small heads and bodies into the focal plane. Canon A2E, 500 mm f/4.5 L Canon, 25 mm extension tube, Fujichrome Velvia, 1/350 second at f/4.5.*

Canada Goose, Waterloo, Ontario. *I like to portray the bird 'immersed' in its environment. At the same time I do not want such elements of habitat to compete with the bird for the viewer's attention. Their graphic significance can be subdued by placing them outside the depth-of-field zone, easily accomplished by selectively focusing on the bird and using telephoto lenses set at maximum aperture for minimum depth of field. Nikon F2, 500 mm f/8 Reflex Nikkor, Kodachrome 64, 1/250 second at f/8.*

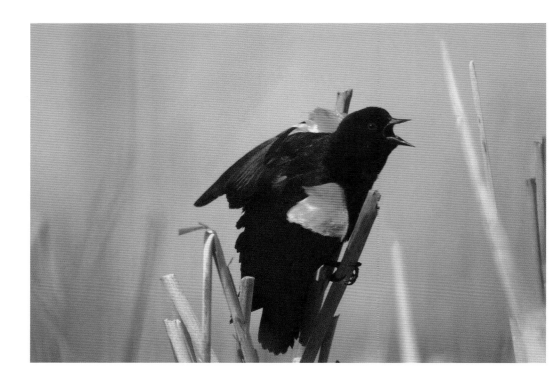

Marsh Wren, Frank Lake, Alberta. *This bird was busy building a selection of nests to win a prospective mate. He gathered building material from one large cattail and stopped his industry occasionaly to launch a song or two. He was so caught up in his deeds that he paid no attention to my efforts at recording his behavior. I shot many frames and finished the design process a week later by editing out the poorer images on the light table. Nikon F2, 400 mm f/5.6 ED Nikkor, 25 mm extension tube, Kodachrome 64, 1/500 second at f/5.6.*

Red-winged Blackbird, Waterloo, Ontario. *In every bird portrait, the subject should be portrayed with the eye sharply rendered, and if possible, showing a sparkling catchlight of the sun's reflection. In this composition, the two warm pools of color, together with the bird's head, build a strong, pyramidal arrangement of important elements. Nikon F2, 400 mm f/5.6 ED Nikkor, Kodachrome 64, 1/500 second at f/5.6.*

compositions. Sharp shapes (beaks, talons, wing-tips, maple leaves) are more attractive than curved ones (breasts, pebbles, aspen leaves).

Lines are used to define space, indicate direction, and link one part of a composition to another. Their lack of expanse causes the eye to move along them, rather than about them. This makes them useful in leading the eye through the picture. Where lines intersect, visual interest is heightened. In bird photography, lines are present as grasses, thin branches, plumes, and ripples in a lake or pond.

Texture is an inherent component of shape and lines. It is the visual manifestation of a tactile sense. Texture lends convincing, sensory immediacy and emotional impact (soft, sharp, delicate, slimy, etc.) to the composition by bringing the image under scrutiny of both the viewer's eyes and fingertips. A subject's texture finds expression through light quality and direction. It is expressed most dramatically by hard, side-lighting, and in greatest subtlety and detail by overcast lighting.

COLOR

Color is an inherent part of shapes, lines, and textures. As the most expressive and powerful visual element, its effect on the composition must be carefully controlled. The strongest colors are the warm ones—yellow, orange, and red. Symbols of energy and action, each draws a unique response from the viewer which can be used to clarify the theme: yellow implies delicacy and

🦩 YOUR NEIGHBORHOOD MARSH *PHOTO HOTSPOT*

SMALL, SHALLOW bodies of water have the most abundant bird life. The relatively large shoreline area supports emergent vegetation (cattails, bulrushes, sedges) which provides excellent reproductive and feeding habitat for birds. Not only are there more birds here than in any other habitat, but they are relatively easy to find and approach for photography. In addition, their watery habitat lends attractive, ever changing features to compositions through reflections, splashes, and ripples generated by not only the bird, but the wind and sun.

In most areas of North America, it is possible to find a wetland a few minutes from home where you can photograph regularly. By becoming familiar with a single location, you will learn in time how the muskrats feed and the herons fish, where the bitterns nest and the snipes fly, when the swans arrive in the fall and the ice breaks up in the spring. You will come to know where the wading is easy, how the light is reflected at sunrise or sunset, and when and where to point the camera.

Chest waders are essential for serious photography. Invest in the neoprene variety which is both warm and durable. Using a super telephoto lens, you may stalk such species as red-winged blackbirds, lesser yellowlegs, avocets, and marbled godwits. But your presence will set off a cacophony of avian protest, especially in the spring, that will soon become intolerable. It is much better to work from a portable blind such as the hoop blind (described on p. 91). Better still, pinpoint an area where birds congregate, such as a mudflat for sandpipers or a loafing log for waterfowl, and set up a blind. Using the same method, it is easy to photograph species that build their nests on mats of floating vegetation, such as the pied-billed grebe and American coot, or those that lay their eggs in a depression on the shoreline, such as the killdeer or American avocet. Whatever your approach, make every effort to be as unobtrusive as possible and the photographic opportunities will increase accordingly.

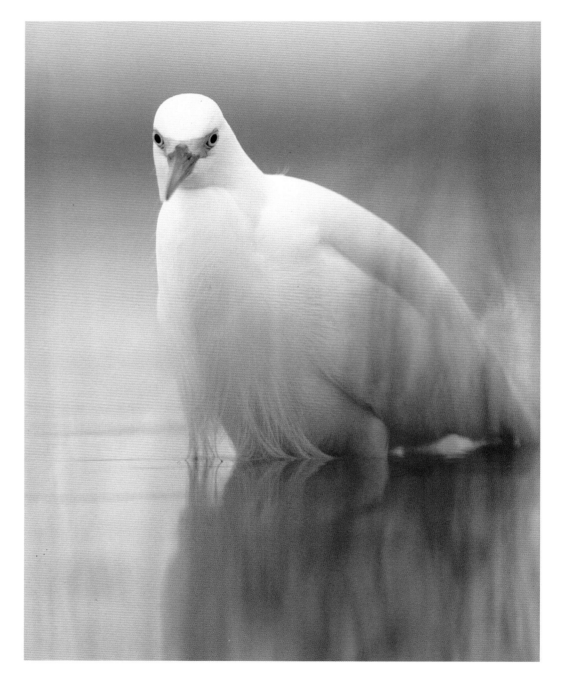

happiness; orange expresses warmth, excitement, and warning; red implies danger, passion, and dominance. The cool end of the spectrum, the shades of blue green, and violet, evoke nearly opposite reactions and support such themes as serenity, freshness, stability, dignity, and wisdom.

STRATEGIES FOR DESIGN

Composition is a process of first recognizing the visual significance of the graphic elements of a scene and then, using various design strategies, organizing these elements so that they express your artistic intentions. Following are some of the choices you must make in carrying out the design process.

• Subject matter.

• Camera position in rendering background, foreground, and subject presentation.

• Point of focus in identifying center of interest.

Snowy Egret, Everglades, Florida. *The use of color in picture design can follow an unlimited number of approaches. The strength of this picture is the result of the absence of color which arrests attention because of its uniqueness and subtlety. Canon F1, 500 mm f/4.5 L Canon, Kodachrome 64, 1/250 second at f/4.5.*

Woodduck Preening, British Columbia. *This species owes its notoriety to the unusual brilliance of its plumage which I tried to show in a direct, simple manner by shooting the bird as it was straightening its finery. Canon T90, 500 mm f/4.5 L Canon, Kodachrome 64, 1/250 second at f/4.5.*

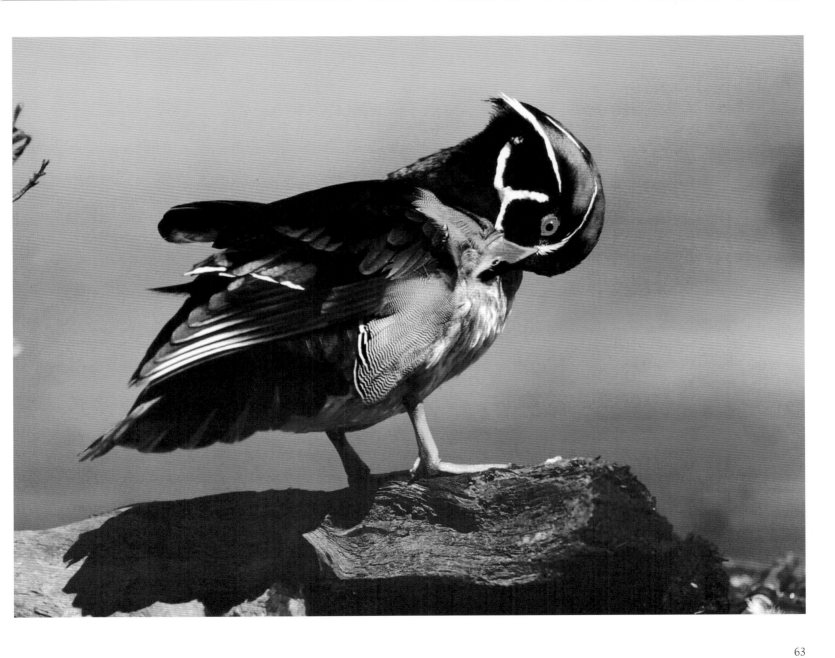

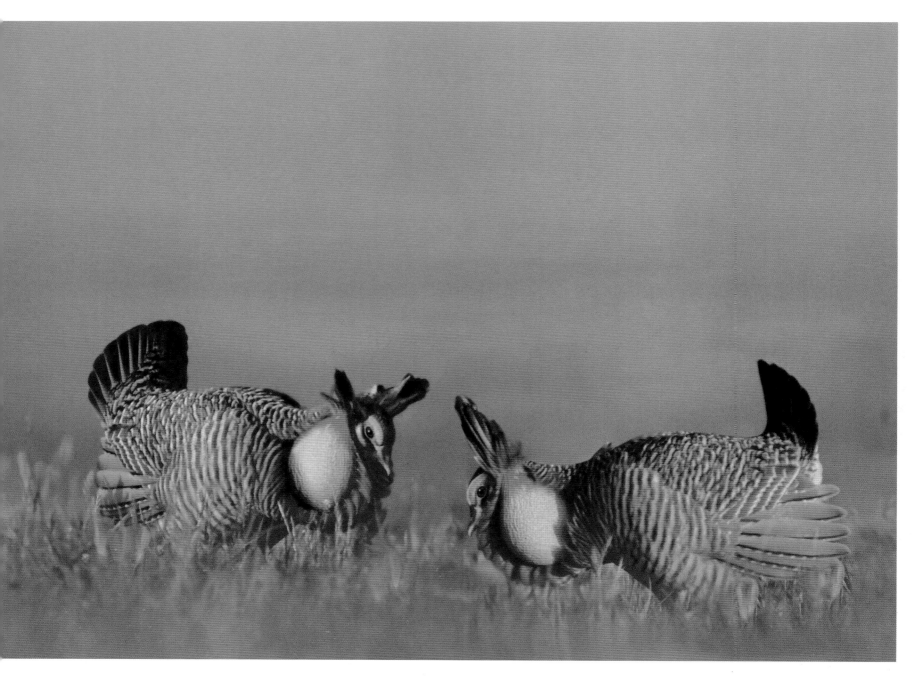

• Lens focal length in determining subject magnification and background expanse.
• Shutter speed in recording motion.
• Aperture size in setting depth-of-field.
• Shooting schedule in utilizing lighting effects and recording subject behavior.

A CENTRAL THEME

The design of each photograph grows from your conception of its central theme. If you are stalking a robin in the backyard, the central theme is exactly that—robin. But more consideration of this apparently simple picture idea is necessary before you start spending film. What is the most compelling expression of 'robin'? You may feel it is its orange breast. With this clarification comes many technical considerations. To show the breast color effectively requires frontlighting or overcast lighting, a fine-grained film such as Fujichrome Velvia or Kodachrome to maximize color saturation, and perhaps even the use of a warming filter. A background setting of green or blue will provide the most dramatic color contrast. You must time the exposure to catch the robin when its breast is clearly exposed to the lens and stationary to insure sharpness.

The central theme of your photograph need not be a specific bird. Your design strategy may be guided by an idea or concept in which the bird places a major expressive role. A theme such as 'wilderness solitude' might be portrayed by a swan gliding over a still, moonlit lake. Happiness might be expressed by a meadowlark singing in a

Sage Grouse Blind, Oregon. *Male grouse gather to carry out breeding displays in the spring on special courtship grounds. They can be easily frightened so I took extra care in setting up this blind, burying and camouflaging it with sage brush the night before I intended to shoot. I entered the blind at four o'clock in the morning, about two hours before the grouse fly in to begin the display which lasts for several hours. They had no idea anything was amiss.*

Sparring Greater Prairie Chickens, Texas. *This photo was made using the same field techniques described above. To bring the grouse closer, I set up mirrors near the blind to simulate rivals and induce display. Despite my efforts, and many good photographs, I nevertheless was unable to catch two birds in clear confrontation. This was solved several years later with the advent of digital imaging techniques which I used to combine the two frames shown above. Canon T90, 500 mm f4.5 L Canon, 1.4X tele-extender, Fujichrome 50, 1/125 second at maximum aperture.*

65

🦩 SOUTHERN FLORIDA *PHOTO HOTSPOT*

FOUND AT THE southern tip of Florida, the Everglades is an extensive, flat, low-lying, sub-tropical region of diverse habitat. Bird life is more abundant here than anywhere else on the continent. Most of the wild land is overgrown with sawgrass and looks like lush prairie. You will be able to easily photograph most of North America's herons and ibises in this habitat, as well as such local specialties as the limpkin, Everglades kite, and black skimmer. Scattered through these marshes are humps of land (called hammocks) covered with stunted trees of tropical origin. These jungle-like confines are home to barred owls, red-shouldered hawks, white-crowned pigeons, various warblers, and other passerine species, many of them tame enough to be stalked in the open with a long lens. Near the sea, the sawgrass gives way to mangrove swamps. These scrubby entanglements are nesting habitat for thousands of wading birds, pelicans, cormorants, and anhingas. Along the coast, in the shallow waters of Florida Bay, you will encounter American oystercatchers, roseate spoonbills, reddish egrets, black skimmers, great white herons, and a diversity of gulls, terns, and sandpipers.

Miami is the main urban centre located about one hour northeast of Everglades National Park. There are smaller natural areas, state parks, and refuges away from the crush of tourists and government restriction where you will find photographic opportunities more abundant and enjoyable. Unfortunately, the heavy traffic and rampant commercial development spell doom for this once rich habitat. Your first visit should be during February or March, when the dry season forces birds to concentrate in alligator holes and ponds.

Outside the Everglade, there is great photography of gulls, terns, herons, and oystercatchers along the beaches and causeways to Key West. The two-lane highway leapfrogs its way for more than a hundred miles over scores of beautiful islands and coves. Ding Darling National Wildlife Refuge on Sanibel Island is a winter haven for waterfowl and many other wetland species. Famed Corkscrew Swamp, an Audubon sanctuary that protects a stand of giant bald cypress, is a nesting site for hundreds of endangered wood storks. For good reason, both refuges attract photographers by the hundreds on any given day in the winter.

field of yellow daisies. Such themes usually require that you record the bird within its environmental context, forging a design which seeks not to sustain visual prominence of a single feature, but achieve a nevertheless compelling artistic statement by the coordination of multiple and often diverse picture elements. Of course, some picture themes cannot be clearly expressed in literal terms but only can be appreciated and understood within the visual context.

Although you cannot always take the photograph you imagine, consciously defining your pictorial goals will clarify the procedures that need to follow and bring the image closer to realization.

CENTER OF INTEREST DESIGNS

Most bird photography attempts to make dramatic portraits of the bird(s) or to capture it engaged in some interesting activity—feeding, flying, or courting. In such compositions, the bird is the visual center of interest. As such, no other features of the design should supersede its visual appeal; nothing should be brighter, sharper, more attractive in color or interesting in texture. With brilliantly hued species like the flamingo or the vermilion flycatcher, the subordination of competing design elements is generally automatic. The majority of species, however, have camouflaged plumage that has evolved to hide them from predators or their prey. To give them visual priority places more demands on your photographic skill.

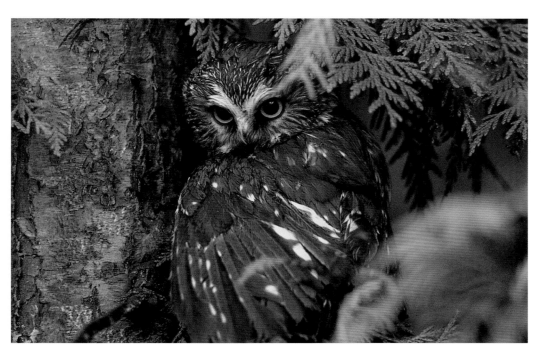

Saw-whet Owl, Vancouver Island. *This subspecies is a small denizen of the west coast rain forests. Its great round eyes and secretive nature are evident in this photo made while the bird was mantling a finch it had taken near one of my bird feeders. Many birds of prey instinctively hide their prey to prevent theft from larger predators. Canon F1, 500 mm f/4.5 L Canon, 25 mm extension tube, Kodachrome 64, 1/60 second at f/4.5.*

Black-winged Stilts, Camargue,France. *Here the central theme is not a specific bird but rather the drama of the relationship between the mother and her three young, one of which has taken refuge beneath the adult's wing. These bird were photographed near their nest from the concealment of a floating blind. Canon A2, 500 mm f/4.5 L Canon, Kodachrome 64, 1/500 second at f/5.6.*

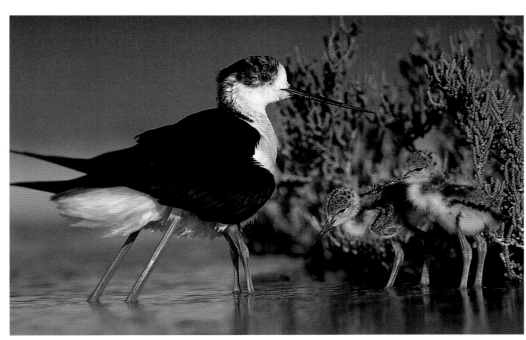

Rufous Hummingbird in Scarlet Gilia, Colorado. *Although in graphic terms it is less attractive than the flowers, the hummingbird is immediately identified as the center of interest because of its uniqueness. As a result of its visual strength, I was able to position it away from the center of the frame and set up a dynamic but well ordered visual flow. Tension results when the eye enters the frame near the middle looking for the main subject; finding nothing significant, it then searches actively about the picture space until it finds the hummingbird. This it studies before returning to the center of the frame, beginning the process all over again.*

Swamp Sparrow, Point Pelee, Ontario. *The sparrow creates a subtle but compelling interruption of the monochromatic color scheme and the rhythmic arrangement of vertical lines expressed by the bulrushes. It not only draws attention to itself as the visual center of interest but accentuates by contrast the simple and pleasant graphic harmonies of the habitat. The sparrow was photographed without benefit of a blind near its nest as it ventured in and out with food for its young. Canon T90, 500 mm f/4.5 L Canon, 25 mm extension tube, Fujichrome 50, 1/250 second at f/4.5.*

PRACTICAL PROCEDURES

There are a number of ways to insure that the bird is the most visually prominent feature of the design.

• *Positioning the subject in the frame.* The location of the center of interest is determined by its relative visual power. The weaker the visual appeal of the main subject, the nearer it must be to the center of the frame. The more eye-catching the subject, the further it may be from the center.

• *Using selective focus.* The more detailed and sharp the design element, the more attractive it is. By focusing on the center of interest, and minimizing depth-of-field, the subject will stand out clearly from background and foreground elements. Long lenses and large apertures maximize selectivity.

• *Adjusting the camera angle to eliminate distractions.* All picture elements in the background or foreground that are brighter, more colorful, or in other ways visually dominant should be eliminated. Position the camera so that the subject is kept away from background elements. For birds on the water or ground, a low camera angle keeps features in the background out of the depth-of-field zone. For birds in trees, adjust the horizontal position of the camera so that the bird is thrown against distant vegetation or the sky rather than nearby branches, trunks, or foliage.

• *Lighting the scene for maximum drama.* Theatrical effects result when the bird is brightly lit while other features of the composition are in shadow.

By anticipating the appearance of birds at predetermined locations (nests, roosts, feeding areas), careful scheduling of the shooting session, and appropriate positioning of the camera, you can achieve indirect control over ambient lighting effects. Reflectors, and in some instances electronic flash, can be used effectively to distinguish the bird with added light.

• *Giving impact to the bird's eye.* Although its graphic appeal may be limited, our attraction to the bird's eye is nevertheless strong because of the importance we place on eye contact in our personal communications. More than any other part of the bird's anatomy, the eye must be in sharp focus, and when possible, catch the reflection of the sun as a sparkling highlight. Electronic fill-flash is a sure way of adding such catch lights, but usually its effect appears artificial.

CONCEPTUAL DESIGNS

Unlike center of interest designs, which are based on visual priorities, conceptual designs are based on sustaining emphasis on the visual relationships of picture elements.

HARMONY AND CONTRAST

Harmony and contrast are opposite and complimentary conceptual approaches that can be used to organize the elements of a design in expression of the central theme. The effective use of either principle requires the elimination of elements which fall outside the central relationships

Tree Swallow on Willow Branch, British Columbia. In visual design, diagonal elements have special strength as they imply movement or instability. They dominate the organization of this composition and provide channels of visual flow which carry the eye back and forth across the center of interest. Canon T90, 500 mm f/4.5 L Canon, 25 mm extension tube, Kodachrome 64, 1/500 second at f/4.5.

Photography in a Swallow Box. The back panel of this box could be replaced with one fitted with a camera; the roof panel with one holding an electronic flash. Once the young were feeding regularly, the switch was made and shooting began. Nikon F2, 20 mm f/2/8 Nikkor, +3 diopter close-up lens, electronic flash GN 40 (ISO 64), Kodachrome 64, 1/60 second at f/16 (exposure balanced for flash and ambient light).

which form the basis of the design.

The principle of contrast organizes not only graphic elements (lines, shapes, textures) but individual pictorial identities (duck, tree, cloud) by comparing their differences. For example, speed may be expressed by the contrast between the sharply rendered body of a flying peregrine falcon and streaks of background color. Here contrast is generated by juxtaposing smooth and sharp graphic elements. Vulnerability might be expressed by showing a turtle dove foraging among the mud-caked hooves of a water buffalo, a theme dramatized by a contrast of subject matter. In each example, there is no single center of interest, but several compositional elements or features interacting with one another. Each aspect of the relationship should receive visual emphasis relative to its positive effect on the theme.

The principle of harmony operates when the composition's graphic elements, especially color, are similar. Imagine an undulating skein of cranes flying over rolling twilight hills, a composition of pastel colors, soft shapes, smooth textures, and sinuous lines. Although these elements exhibit recessive visual characteristics, their co-ordinated effect generates a compelling image. If building a harmonic design, discordant elements should be eliminated.

RHYTHM

Rhythm, the most visually pleasing of design strategies, derives from a repetition of graphic

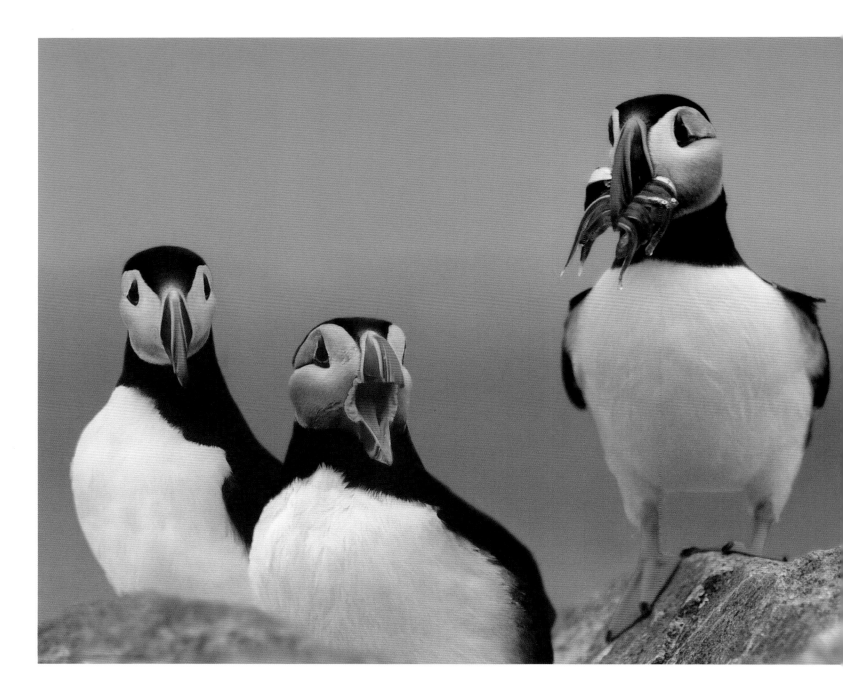

elements or pictorial features that results in a pattern—a repetition of accent and interval. Rhythm is used as a design strategy when photographing groups of birds—sandpipers massed on a pebble beach or a line of ducklings following their mother. Rhythm may be used as a supporting design feature in compositions based on a center of interest—a formation of aspen trunks as a roost for an owl or a spray of droplets coming off a shaking grebe.

Most natural rhythms require refining. Among the many controls available to the photographer, the most useful is the timing of exposure to capture animated subjects when the pattern is most evident. Rarely will you come upon a pattern that is too uniform. Adjustment of camera angle can also be a simple and effective way of eliminating elements which distract from the rhythm.

MOTION PHOTOGRAPHS

Whether you choose to reveal the activity of the subject as frozen or blurred, the result is usually a strong image because it shows the viewer

Atlantic Puffins, New Brunswick. The dramatically formal and uniform pattern of puffin plumage encourages visual comparison, beckoning the eye to shift systematically from bird to bird to search for similarities and differences. The simple, featureless background provides an unobtrusive setting which deflects interest to the birds. Canon T90, 500 mm f/4.5 L Canon, Fujichrome 50, 1/350 second at f/4.5.

🐦 SOUTHEASTERN ARIZONA *PHOTO HOTSPOT*

MY FAVORITE birding area in the United States, the dry, hot, and rugged region of southeastern Arizona offers many attractions aside from an agreeable climate and stunning landscape. Especially unique is the Sonoran desert, a magical habitat of giant saguaro, cholla, prickly pear and many other cacti, ocotillo and sagebrush, mesquite and palo verde trees, and wildflowers in early spring. Here the birds are strong-voiced, easily spotted, and abundant. The desert areas are spread among various mountain ranges, which produces a variety of other habitats—shaded river canyons lined with sycamores, oaks, and cottonwoods; foot-

hills covered with pinon pine and juniper; and mountain sides where ponderosa pine and Douglas-fir project from lingering snowpacks. This variety of habitats is matched by a diversity of birds. Many species are only found in the Southwest. Local desert specialties are the roadrunner, cactus wren, Harris hawk, white-winged dove, pyrrhuloxia, curve-billed thrasher, gila woodpecker, and Gambel's quail. In the mountains (the Chiricahua range is

best), you will encounter new species of birds whenever you gain or lose elevation: brown towhees and acorn woodpeckers in the foothills, black-headed grosbeaks and western tanagers at mid-elevation, and mountain chickadees and Steller's jays at the summit—to cite a few examples. Of special appeal are the many canyons scattered through southeastern Arizona. You will want to visit Sabino Canyon, Madera Canyon, and Ramsey Canyon. Southeastern Arizona is the hummingbird capital of the United States, with more than a dozen species. There are hummer resorts where humans have set up feeders attracting hundreds of birds everyday. Any time is good, but late summer rains bring out the wildflowers and bring in the hummingbirds.

This diversity of species requires a similar variety of photographic approaches. The area is frequented by bird lovers who have conditioned the local avian population to visit feeders. Setting up your own is usually a quick way to bring a selection of confident local birds within camera range. Phoenix and Tucson are convenient big city staging centers.

Black Oystercatcher, Washington. *This design is based on the contrasting graphic elements of the oystercatcher and the heron: large vs. small, blur vs. detail, and light vs. dark. The sun's angle illuminated the birds but left the distant forest in shadow providing a smooth, color-neutral back- drop that allows a clear analysis of the relation- ship between the birds. Canon F1, 500 mm f/4.5 L Canon, Kodachrome 64, 1/250 second at f/4.5.*

something that is difficult or impossible for the naked eye to see and appreciate. Motion is con- trolled by choice of shutter speed and camera panning.

With stop-action photographs you must use a shutter speed fast enough to freeze all movement in the scene. Except for small species, such as songbirds and hummingbirds, 1/1000 second is sufficient to arrest bird movement, including full flight, although there may be some blurring of the wing tips.

Unfortunately, neither lenses nor fine- grained films are fast enough to freeze the motion of smaller species. The usual solution is to use electronic flash which freezes action by virtue of the flash duration which can be as brief as 1/ 40,000 second. Such images are usually infused with the artificial overtones of the studio and do not convey the sense of the bird in the wild.

For blurred motion photographs, choice of shutter speed is critical—too slow and the subject becomes an unidentifiable wash of color, too fast and the effect is ambiguous and confusing.

The results of blurred motion photography are unpredictable, so take lots of pictures and edit them once the film is developed. The shutter set- ting depends on the speed of the subject which varies with its size (the larger the bird the slower its movements), its activity, and the direction it is moving relative to the camera. Birds approaching the camera head-on generate less blur than those moving across the field of view.

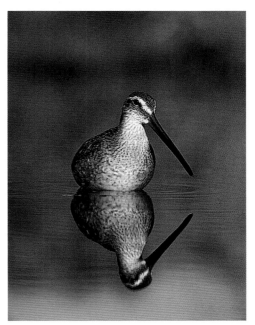

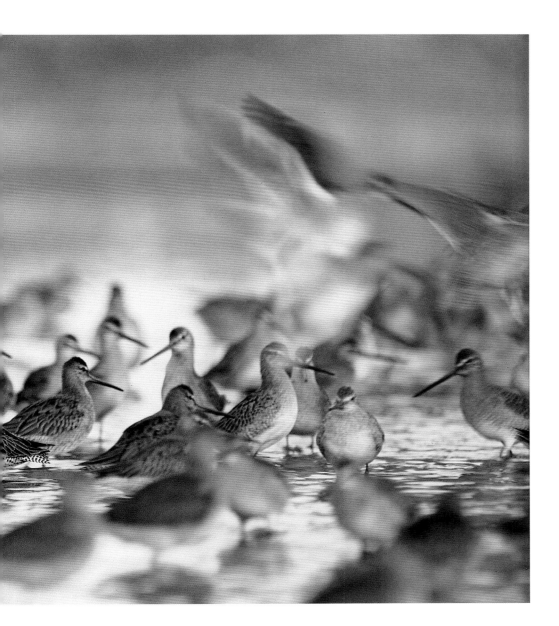

Long-billed Dowitchers, Washington Coast. *Of the artistic approaches you might explore in photographing birds, none is likely to bring you more surprises and creative satisfaction than experimenting with the effects of moving subjects. While photographing these dowitchers in the dim light of mid-winter, a few of the birds swirled up in flight during one of the long exposures creating an abstract impression that I could not have predicted. Canon F1, 500 mm f/4.5 L Canon, Kodachrome 64, 1/15 second at f/4.5.*

The Digital Darkroom. The basic components of my digital darkroom are shown above.
•The computer itself should have the largest hard drive, fastest processor, and as much ram as you can afford due to the large size of color images (up to 32 megabytes).
• A 35 mm slide scanner for converting your photographs to digital files. The most important specification, aside from scanning speed, is the scanner's dynamic range (its ability to record shadow detail) which should be at least 3.0.
• Editing Software—Adobe Photoshop is the most widely used application.
• A high resolution color monitor (17 inches is large enough) with a color graphics accelerator for fast screen redraws.
• A tape (DAT) drive for storing your images. A single tape costs about as much as a roll of film and can store 200 images or more. You can send these tapes to service bureaus for output to prints or slides.
• For the beginner, a handy telephone for getting technical assistance while you are working.

By panning the camera with a subject moving across the field of view, a sprinting roadrunner or swooping marsh hawk, for example, a measure of sharpness is preserved in the subject (ideally enough for identification) while the background dissolves into a rushing stream of color. Panning on a laterally moving bird with a 200 mm lens will yield attractive results with a shutter speed of 1/30 second. Longer lenses will usually require faster speeds but actual subject magnification and speed are the critical factors. The most dramatic effects result when the background has strong and varied colors.

QUICK DESIGN TIPS
• Get close and stay low.
• Shoot at maximum aperture for minimum depth-of-field.
• Focus on the eye; catch a highlight if possible.
• Shoot under natural light at sunrise and sunset.
• Include strong color if using frontlight or light from an overcast sky.
• Keep the background and foreground darker than the bird.

THE DIGITAL DARKROOM
It is the stated policy of the National Audubon Society not to use any photographs which have been produced by means other than in-camera methods, such as double-exposure, artificial filtration, photo-montage, or digital manipulation in any Audubon publications intended to present factual or scientific information. However, the National Audubon Society recognizes that images that result from out-of-camera techniques, both those long established and newly developed, such as digital imaging, are valid expressions of the artistic spirit provided they are clearly identified or readily perceived as works of art rather than documentary representations of nature.

A desktop scanner converts photographs into digital codes that can be manipulated on a computer monitor almost as easily as brushing paint onto a canvas. You can sharpen part or all of the image, adjust color balance and saturation, eliminate hotspots and distracting features of the background, repair scratches and remove dirt spots,

Prairie Falcons at Delicate Arch, Utah. I used four photographs to make this digitally composed image. I replaced the sky in the base scenic photograph with one that was more dramatic. I then dropped in the prairie falcons which were photographed in Alberta. The image is not a real depiction of nature, but it is done in a realistic style which results in a surrealistic effect.

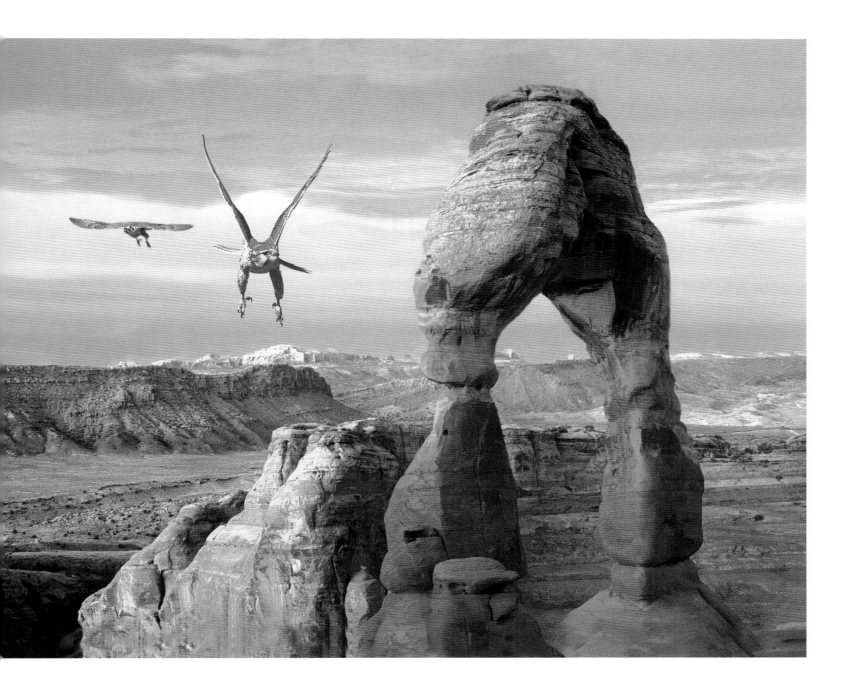

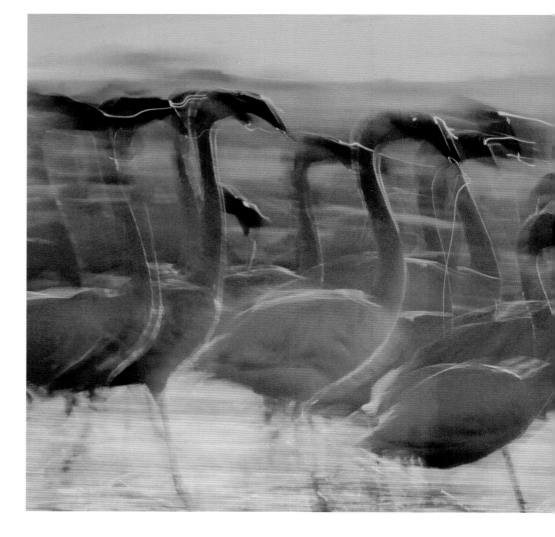

Lesser Flamingoes, Kenya. *Computer imaging is not the only way in which you can create images which depart from those made by standard one exposure/one image procedures. Multiple exposure techniques, whether completed in the camera on the same frame or combined afterward by sandwiching the film, offer many possibilities. In this composition, I sandwiched two slides: the blurred motion shot of the flamingoes, in itself dramatic due to the tracings of glistening water droplets, and a richly colored shot of the sky. I then re-photographed them to correct the density and contrast. Although the picture makes no attempt at realism, for me, it is an accurate expression of the nearly overwhelming visual experience that I had photographing hundreds of thousands of restless flamingoes at sunrise.*

add a catch light to the bird's eye, re-arrange the angle and position of wings and legs, embellish plumage, and create photo montages or seamless new designs by combining pictorial features from an unlimited number of transparencies. Almost anything imaginable can be created in expressionistic or photo-realistic style. The photographs you make in the field become the compositional basis for the image that will be assembled using mouse and keyboard. Instead of arranging pigments on canvas, you are manipulating bits of light that have been captured by the camera and stored by the computer. As potentially beautiful as those that flowed from the brushes of Audubon and Fuertes, such images of the natural world blur the boundary between

painting and photography, in the process greatly expanding the creative possibilities available to you.

Learning to use computer technology is as challenging as learning traditional in-camera techniques. Using it effectively requires many of the same skills of the painter. It is a tool which facilitates artistic expression. In so doing, it eliminates

POINT PELEE *PHOTO HOTSPOT*

THIS FLAT spit of land, projecting southward into Lake Erie for fifteen kilometers (nine miles) has long been a mecca for bird enthusiasts. About an hour's drive from Detroit or WIndsor, Point Pelee is thought by many birders to provide the most dramatic show of migrating species anywhere on the continent. Most of the area is preserved inside Point Pelee National Park. One of the best times to visit is May, and if bad weather descends on Point Pelee from the north, there will be an exciting "fall-out" of birds. Crossing Lake Erie into the wind, northbound migrants make for Point Pelee, the nearest landfall. Arriving exhausted and unwary, they are awaited by eager photographers from all over the world. During a storm in mid-May, the peninsula will be alive with tanagers, flycatchers, orioles, vireos, grosbeaks, buntings, thrushes, swallows, and especially warblers. Single day counts in the fall have recorded 500 horned grebes, 1,000 sharp-shinned hawks, 26 saw-whet owls, 10,000 blue jays, 2,500 blackpoll warblers, 3,500 cedar waxwings, and 120,000 common terns, to cite only a few species. Southward migration

lasts from mid-July to early November. Peak numbers of land birds pass through during September, often in intermittent waves. Even though Point Pelee is small and isolated amidst heavy agricultural and suburban development, it is more than just a turnstile for migrants. Its varied habitat—mature hardwood forest, cattail marshes, overgrown fields and orchards, brush, beach dunes, ponds, and of course, open lake—meet the reproductive and feeding requirements of many species. Convenient access into the marsh is provided by nearly a mile of boardwalk which leads to an observation tower. Bring your longest lens and be prepared to do some quiet tramping through the underbrush—birds may be found anywhere during migration.

Point Pelee is also known for migrants other than birds, including dragonflies, monarch butterflies, and bats. Nearby Jack Miner's Bird Sanctuary is an exciting staging area for large numbers of geese and ducks. Best seen in late March, early April, and late October, it provides good opportunities for photographing masses of waterfowl in flight.

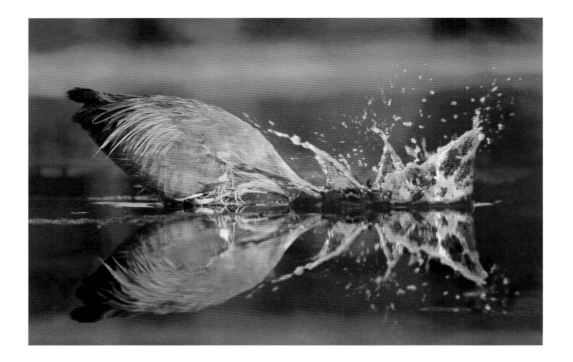

Great Blue Heron Fishing, Vancouver Island. *In the original image, the great splash which suddenly erupted as the heron lunged for its dinner was constrained by tight framing. There was no room to absorb the momentum of the water and so the composition was weakened. I used Adobe Photoshop software to, in effect, pull back from the scene, reducing the relative size of the heron to provide a more visually comfortable setting for this dramatic moment. Canon F1, 500 mm f4/5 L Canon, Kodachrome 64, 1/500 second at f/4.5.*

Black Oystercatchers, Vancouver Island. *To portray this event in the life of an oystercatcher would be impossible using only in-camera techniques due to the extent of the depth-of-field necessary to capture both birds in focus. Instead they were photographed separately and combined by digital imaging.*

means of communication premised on the objective transfer of information.

BUYING A SCANNER

Photography shops offer slide scanning services for as little as one dollar per scan. The photographs are scanned onto CD ROM which you then transfer to your computer's hard-drive. This is a low cost way to become acquainted with the process of digital imaging. Should you become committed to it as a means of photographic expression, you will want the convenience and creative spontaneity that a desktop scanner provides.

Value in a scanner is a function of its resolving power (recommended minimum of 2700 dots per inch) and its dynamic range (3.0 or greater recommended) which is a measure of the scanner's ability to capture detail from highlight and shadow areas simultaneously. A good desktop scanner will cost about as much as two high performance camera bodies.

As digital images, your photographs can be manipulated using commercial image editing software, the most popular being Adobe Photoshop. Scanners generate images with over 30,000,000 individual parts or pixels (think of them as grains in a film emulsion) which can be individually moved, tinted, deleted, replaced, copied, and subjected to many other software effects. Digital images from scans can be viewed on your monitor, printed on a color printer, or reverted to high quality 35 mm or larger transparencies. Both

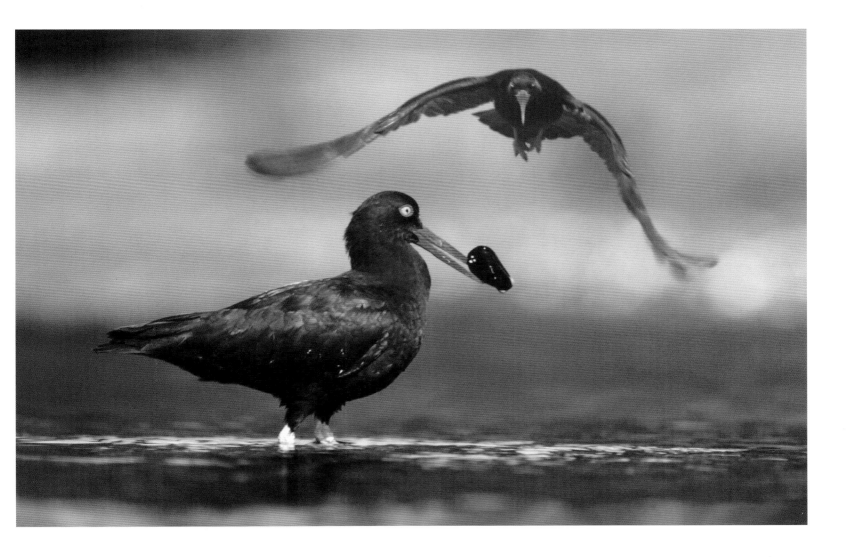

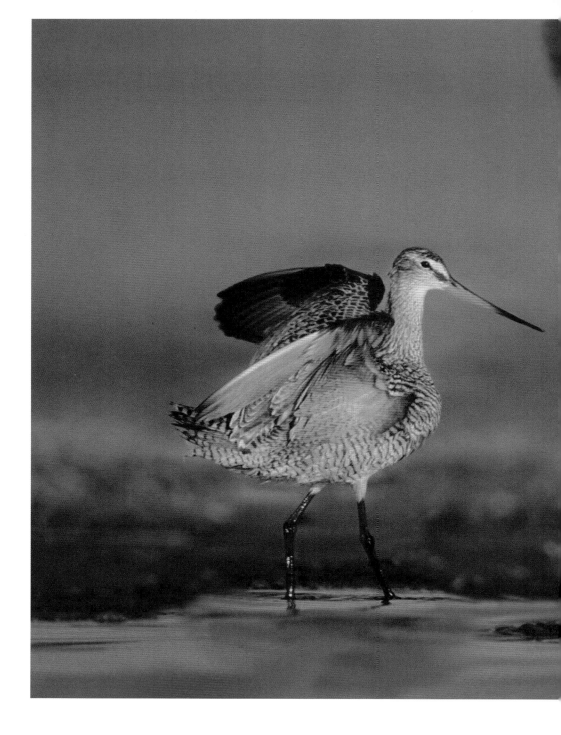

Marbled Godwits, Alberta. *Digital imaging technology can change the way you approach photography in the field. It is still necessary to make the sharpest and best exposed images possible, as the computer's output is limited by the quality of the input. It cannot, for example, bring convincing sharpness to a soft image or create natural features. The technology is good, however, at creating seamless combinations of several photographs. The most realistic images result when the birds and backgrounds are similar, such as in the accompanying example. In all cases, except those seeking abstraction, you must draw on the same skills of the painter to ensure that color, light, shadow, perspective, proportion, and all the other elements of realism are skillfully handled.*

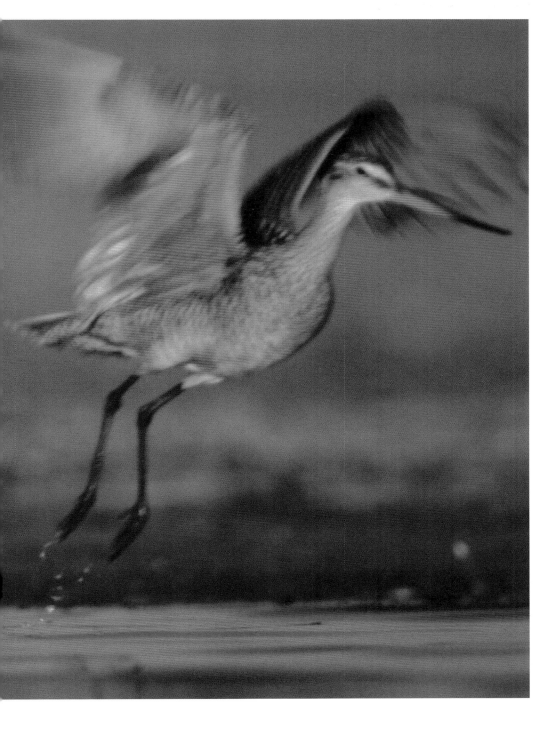

paper and transparency printer output can attain conventional photographic quality.

Such color images use up millions of bits of information. To deal with these multi-megabyte files, you cannot have a computer that has too much memory (ram), too large a hard drive, or too fast a central processing unit (CPU). An efficient system presently costs more than all of the camera equipment you would need for photographing birds in the field. However, prices for such equipment tend to fall rapidly once they become established in the market place. Less powerful systems produce the same quality images, but take longer to do it.

ART AND DESIGN

The magic that transforms a photograph into art cannot be practised or learned; it cannot be manufactured from cameras or computers. It is inherently a product of the photographer's expression as an artist, a reflection of his abilities, experiences, and unique character. With time your approach to picture design will become intuitive rather than logical and on those sunny mornings when good fortune and the birds fly in your direction, art will replace illustration.

In the Field
with Elusive Subjects

NOT WITHOUT REASON are birds afraid of humans. It makes getting close enough for detailed photographs difficult. Long lenses help but they are only part of the solution. Joining other photographers in areas where the birds are either unafraid (Antarctica) or conditioned to human proximity (Corkscrew Swamp) produces great photos, but it is just as satisfying to make a unique record of the splendid plumage of the towhee that nests in the woods down the road. To do this, you must hide yourself in a blind, a stratagem that fools most birds most of the time.

BIRD SAFETY FIRST

Even when using a blind, you may unknowingly cause harm to the bird unless you are aware of the hazards. Birds have evolved to cope with natural stresses but have very low tolerance for the intrusions of a photographer. The energy they spend avoiding you may be needed to find their next meal, escape a predator, or continue migration. If a bird is upset by your presence—calling, threatening, flitting about restlessly—

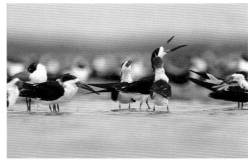

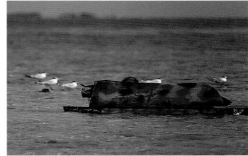

Black Skimmers, Flamingo, Florida. *A blind, such as the floating model used to photograph these skimmers, is the best way to insure that your photographic endeavors are not troubling to the subject. At the same time, a blind allows you to work at close range with birds that are relaxed and engaged in natural behavior. These skimmers were photographed on a sandbar in Florida Bay where they regularly gathered at low tide. Canon F1, 500 mm f/4.5 L Canon, Kodachrome 64, 1/250 second at f/4.5.*

Prairie Falcon, Alberta. This falcon's nest was located in the mouth of a cave high on a cliff face. I crawled past the nest and hung up a fabric screen to shield me from the parents once they returned from hunting. I was curled up behind the camera about two feet from the nest when the young were fed a ground squirrel. Nikon F2, 43-86 mm Nikkor at about 80 mm, electronic flash, Kodachrome 64, 1/60 second at f/11.

Cliff Blind. The hoop blind discussed later in this chapter can be set up in a variety of locations. It can be suspended from tent poles that have been driven into the ground, hung from a tree branch, or suspended on a simple wooden pole with shoulder straps and worn by the photographer like a back pack.

Long-eared Owl, British Columbia. Most owls can be cautiously approached without a blind. They are more active on cloudy days. Should you come upon one, it is likely to be lethargic which makes it difficult to capture an alert expression. I carry a toy mouse attached to about 40 feet of fishing line which can be tossed out and retrieved in plain view. It is a subtle and effective way to perk up the subject.

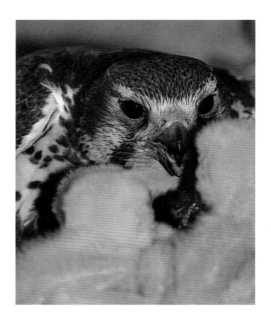

you need to give it more space without delay. Persisting rarely results in a worthwhile photograph, and in any case, the picture would be an unpleasant reminder of your callousness. Only by conscientiously studying the patterns of bird behavior, will you be able to safeguard your subjects, as well as predict and direct their behavior to photographic advantage. Reproduction and food procurement occupy much of a bird's active hours and provide the best opportunities for photography.

NATURAL COVER

The natural landscape offers easy and effective ways to conceal yourself. You can hide in the vegetation if it is thick enough, or use it to assemble a screen or even a full blind. Brush, log piles, trees, stones, bales of hay, and earthen excavations can be adapted to hide the photographer. Wear camouflaged clothing, particularly on your hands, face, and any other part of your body that moves. Attach a piece of transparent camouflaged netting to the inside of your hat brim that can be lowered over your face. Your equipment, including tripod, can be disguised with camouflage tape, or spray paint. Camouflage products can be purchased in rod and gun shops.

WORKING FROM BLINDS

A blind is a box-shaped structure made of fabric stretched over a framework large enough to conceal a seated photographer. Building one is

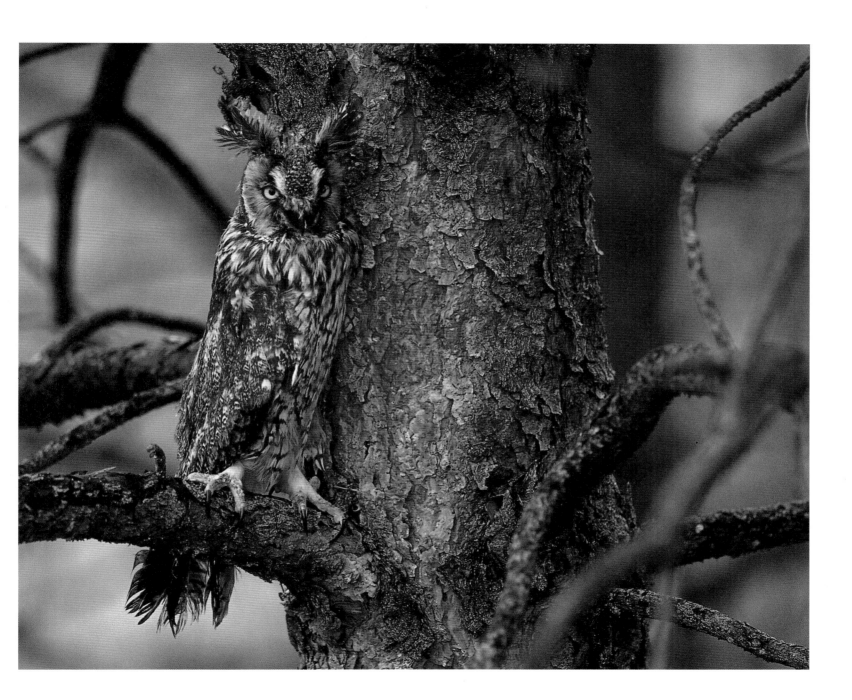

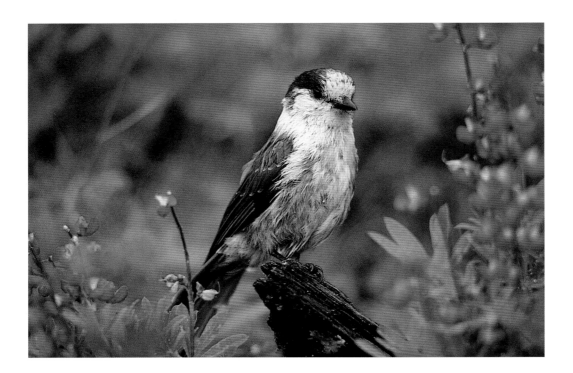

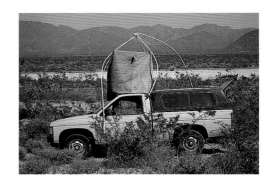

Gray Jay, Mount Rainier, Washington. *This bird was accustomed to feeding on the leftovers and hand-outs at a popular picnic area. I used peanut butter to lure this conditioned subject into a photogenic setting among alpine lupines. A thin smear of peanut butter makes excellent bait. It is easy to hide and cannot be carried off by the subject to be consumed out of camera range. Canon T90, 500 mm f/4.5 L Canon, Fujichrome 50, 1/125 second at f/4.5.*

Blinds. *You can use any method that works to hide yourself from the bird. Most species are oblivious to strange structures that suddenly appear in their habitat, though they may seem incongruous to us. Often you must leave the blind unattended for several days or even longer. Expensive, commercially manufactured blinds are impractical because of the likelihood of theft. I set up the blind on top of the truck when photographing a red-tailed hawk nesting in an ocotillo bush. It is supported by plastic pipe and lots of tape. I had no assistant to escort me into the blind, so I brought the truck up to the nest in stages across the desert, and when the parent left, crawled out the side window and slipped into the blind.*

easy and it allows you to customize it to your size, the habitat, anticipated use, and local materials.

• Use inexpensive materials so you can leave the blind unattended without worrying about theft.

• Make the blind portable by using lightweight fabric such as ripstop nylon and flexible, plastic plumbing tubing for the frame.

• Make new openings in the blind whenever necessary to attain the best camera position. A knife and a tube of instant fabric glue are all you need to adapt the blind to unusual situations.

• Match the color and pattern of the fabric to the terrain to reduce human notice of the structure.

MOBILE HOOP BLIND

Nearly as easy to make as a conventional blind, the hoop model has a number of advantages. Its circular shape is less affected by wind. The accordion structure adjusts to a range of heights, allowing you to shoot from standing, sitting, or even prone positions. It can be used in marshes, lakes, and tidal areas that are normally rich in bird life. The hoops float so that the blind's height adjusts to changes in water depth that occur when stalking.

A hoop blind can be made with readily available materials (see caption). It is also manufactured commercially (see the Appendix).

AT THE NEST

Photography of nesting birds carries considerable risk of disturbing the

🦤 HUMMINGBIRD HOTSPOT

YOU CAN PHOTOGRAPH these tiny birds by setting up feeders during the warmer seasons. A clear glass feeder gives the hummingbirds good visibility all around, allowing them to relax and feed for longer intervals which allows more time for focusing and framing. The nectar should be composed of four parts water and one part white table sugar. Never use food coloring, honey, or premixed nectar. Place the feeders in an area which will receive good light in the early morning. Keep them low to the ground and near natural feeding plants. If unwanted bees, wasps, and ants begin to take over the feeder, dilute the sugar/water mixture one to five. Since

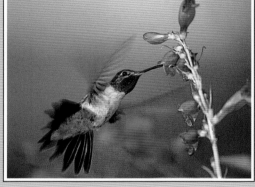

bees like yellow, paint the yellow plastic flowers and bee guards that may be on your feeder with red nail polish. You also will want to attract hummingbirds by planting tubular flowers such as lupines, gilias, and penstemons.

In order to photograph a hummingbird in a natural setting, it is necessary to transfer its foraging patterns from the feeders to wildflowers. This can be done by replacing the feeder with appropriate species of potted wildflowers just before a photographic session. The hummingbird will be confused at first, but quickly give the natural offering a try. To keep the subject

coming back at regular intervals and narrowing its preference of nectar sources, I fill individual flower blossoms with the sugar/water mixture using an eye dropper. The hummingbird learns to come to the loaded blooms allowing you to make the necessary preparations so that photography can begin without delay. Hummingbirds like to feed facing the wind, so you may wish to set up a small fan to keep your subjects oriented correctly.

Lenses of 200 mm and longer, equipped for close focusing, provide adequate magnification. I like natural light which requires a lens with an aperture f/4 or larger and a film of ISO 100. Under sunny conditions, this permits exposures of 1/350 second or faster in early morning, enough speed so that the wings do not completely disappear but register as a prominent blur. Frontlighting, either from an on-camera fill-flash (used for this photograph) or from the sun, will light up the male's colorful gorget. You also may wish to stop all hummingbird movement using a full electronic flash set-up. This provides exposure times of 1/30,000 second—possible with some standard non-TTL flash units set at low power. See the sidebar 'Hollywood Woods' on p. 93.

breeding cycle or causing nest failure for all but the most experienced nature photographers. It should be undertaken only by those with a thorough knowledge of bird behavior (particularly the subject species), extensive ornithological field experience, and advanced photographic skills.

During the breeding season, the nest site predictably provides subjects for photography. However, if disturbed, the bird may abandon its nest, leaving its young to starve, die of exposure, or be taken by predators. The utmost consideration of the bird's welfare is required.

THE REPRODUCTIVE CYCLE

You must become familiar with the reproductive vagaries of each species before you begin photography at the nest. In the Appendix, you will find a list of reference texts that provide the information necessary to develop adequate knowledge to attempt this kind of work. Although there are many exceptions, most species follow the reproductive steps described below for an average-sized songbird (cardinal, robin, blue jay). Each stage lasts about two weeks; smaller birds take less time, larger birds take more time. The shooting schedule should be drawn from the broad-based research of the reference literature.

Territoriality. The male claims a territory that

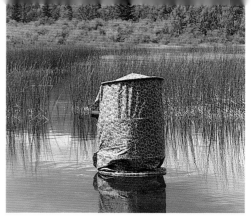

Making a Hoop Blind. *You will need five to six yards (54 inch width) of nylon fabric, contact cement, hula hoops or flexible plastic pipe, and duct tape.*

1) Cut fabric into two equal pieces the same length as your height. 2) Glue pieces together long side to long side. 3) Sew four equally spaced hems (to hold the hoops) lengthwise. 4) Insert hoops; refasten hoops with duct tape. With plastic pipe, use commercial joiners. 5) Cut out and glue roof piece onto wall. 6) Cement open sections of walls together. Leave top section open for camera projection.

Barn Swallows, Utah. *These swallows regularly used some branches near their nest to court one another. I was able to bring my car within camera range and photographed them through the passenger window. I had a tripod set up beside me in the front seat and the windows draped with camouflaged netting. Canon T90, 500 mm f/4.5 L Canon, Kodachrome 64, 1/500 second at f/4.5.*

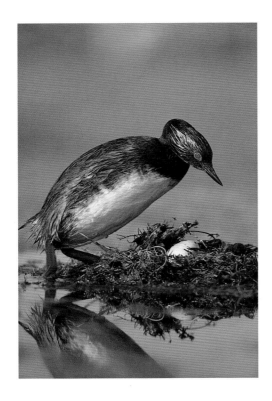

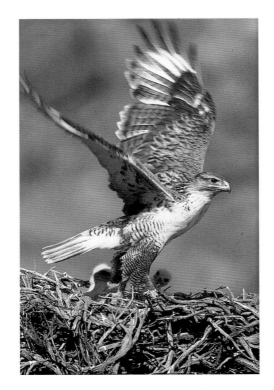

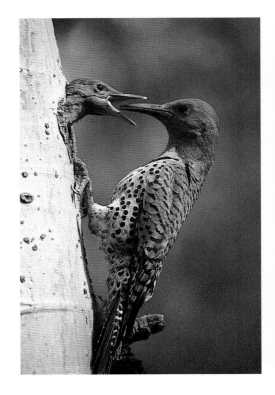

Eared Grebe, Alberta. *Like many water birds, young grebes leave the nest shortly after hatching, making it necessary to photograph during the incubation stage—something you must not do with species whose young hatch naked and helpless. Fortunately, many species with precocial young are not readily upset by the appearance of a blind. Schedule your shooting toward the end of the incubation period when the parents are the most steady on the nest and you have a chance of recording the hatching process. Sometimes you can judge the stage of incubation by the appearance of the eggs; the older the egg, the dirtier it is. Eared grebe eggs are whitish blue when laid and rich brown just before hatching.*

Ferruginous Hawks, Idaho. *For birds of prey, the best time to begin photography at the nest is when the young are alert—sitting up and snapping at flies—but still have downy plumage. At this stage they are strong enough to tolerate the disruption that shooting may cause, yet they are too weak to dismember the prey that the parents bring, providing opportunity to photograph the family altogether at meal time. Canon F1, 500 mm f/4.5 L Canon, Kodachrome 64, 1/500 second at f/4.5.*

Northern Flickers, Colorado. *Woodpeckers are best photographed when the young are nearly ready to fly. At this stage in their development, their heads come poking out of the nest when the parents approach and they cry to be fed. Earlier in the cycle, the parents will disappear into the nest hole to feed the small young out of sight of the camera. Canon T90, 300 mm f/4 L Canon, Fujichrome Sensia 100, 1/250 second at f/4.*

will provide a satisfactory nest site and adequate food for its future family. This is done by exuberant singing and displays. The territory is protected against invaders of the same species only. **Do not attempt photography but watch from a safe distance during this phase.**

Courtship and Nest Building. Females are attracted to the displays of the male, a pair bond is established, and the nest is built. Displays continue. **Watch only from a safe distance.**

Egg laying and Incubation. Each egg is laid soon after copulation which lasts only a few seconds or less, often completed in flight. One egg is laid each day until the clutch is complete. The eggs are warmed for roughly two weeks by either or both sexes until hatched. **Watch only from a safe distance.**

Care of Nestlings. Either or both parents bring food to the young until they are ready to leave the nest about two weeks after hatching. **Set up the blind and begin shooting about one week after hatching. Stop photography three to four days before the young are ready to leave the nest.**

Care of Fledglings. The parents continue feeding the young away from the nest for several weeks. **Photography may be resumed by cautious stalking of the young birds which draw the parents. Should the parents become alarmed, do not attempt further photography.**

🦆 HOLLYWOOD WOODS *ELECTRONIC FLASH*

ELECTRONIC FLASH IS frequently used on subjects when natural light levels are too low to enable the use of action-stopping shutter speeds—hummingbirds in flight or songbirds in dark forest settings. As you would expect, the results are artificial and of limited artistic value. However unimpressive electronic flash photography may be to some, such images can be very revelatory and full of scientific information.

Flash exposure is normally controlled by the camera's TTL (through-the-lens) sensor. Multiple flash units are linked and connected to the TTL sensor via special cables. Flash duration actually determines the duration of exposure, regardless of the shutter speed; the fastest speeds arise when the flash is set to high power and

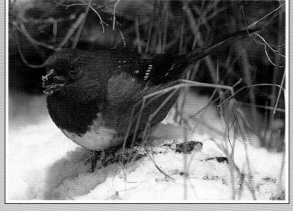

the lens aperture is set to maximum. It also helps to keep the flash(es) close to the subject.

There are ways that the artificial effect of the flash may be minimized. Several flashes should be used simultaneously and positioned so that all parts of the scene receive levels of illumination approximating morning sunlight. Avoid using the standard lighting arrangement used for making human portraits (one flash at the camera, the second above and to one side of the camera, the third directed at the background). Instead place two flashes to the side of the subject, making sure that the background receives its share of illumination to avoid under-exposure that would black it out. Place a third flash on the opposite side at reduced power (two stops) to simulate natural fill light normally reflected from rocks, trees, grass, or other features of the landscape. Use diffusers over the flash heads to simulate the effects of sunlight broken up by clouds. If the setting and subject permit, rather than a third fill light, use a sheet of styrofoam reflector board.

Finally, reduce the illumination levels if necessary so that larger apertures can be used to produce shallow depth-of-field. Also, use the super telephoto lens that you use in the field to maintain the same perspective and limited depth-of-field that results under natural light conditions.

Although, these procedures may seem complex, they will help you avoid producing images that appear to be shot on the back lot at Paramount and at the same time allow you to utilize the stop-action advantages of electronic flash.

Tree Blind in Heron Rookery, Ontario. *In order to ensure minimal disturbance to the rookery, I set up this blind among a group of nests during the winter when the birds had migrated south. On their return they accepted the blind as a natural part of the habitat and several nests were occupied within photographic range.*

Broad-winged Hawks, Ontario. *With the help of two assistants, I set up a tower and blind at this nest in two brief stages. A two hour session in the blind the following day was enough to attain good photographs of the hawk family. The next day we returned and quickly removed the blind, minimizing our intrusion into the birds' territory. Canon T90, 500 mm f/4.5 L Canon, Fujichrome 100, 1/90 second at f/4.5.*

SETTING UP THE BLIND

To minimize disturbance to the bird, tight organization and preparation of materials should be made before approaching the nest to set up the blind. Limit work periods to 15 minutes. Do not work at the nest site during the heat of the day or during periods of precipitation or high wind. Do not begin erecting the blind until several days (or more for larger species) after the young have hatched. For precocial species—those whose young leave the nest shortly after hatching, such as shorebirds and waterfowl—delay erecting the blind until the last few days of incubation.

Set up the camera first in the most photogenic spot and then erect the blind over it. Place an object the size of the adult bird temporarily at the nest site to help judge framing and magnification requirements. Carefully evaluate the background and lighting for compositional strength. **Vegetation around the nest is needed for protection against the elements and predators and should not be removed.** Once the camera position is established, erect the blind in two or three stages over the period of two or three days. While working, be careful not to tramp obvious trails to and from the site which will make it easy for predators to find the nest.

After setting up each stage, move to a safe distance and observe the reaction of the bird(s). It should return to the nest with little hesitation. If it agitates for more than five minutes, return quickly to the site, gather up your equipment and

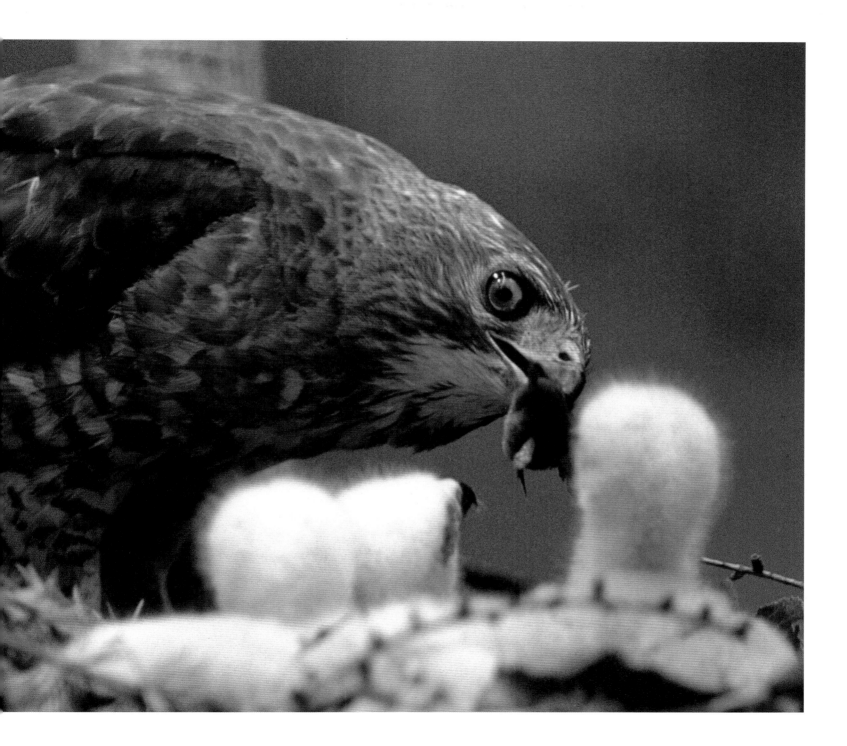

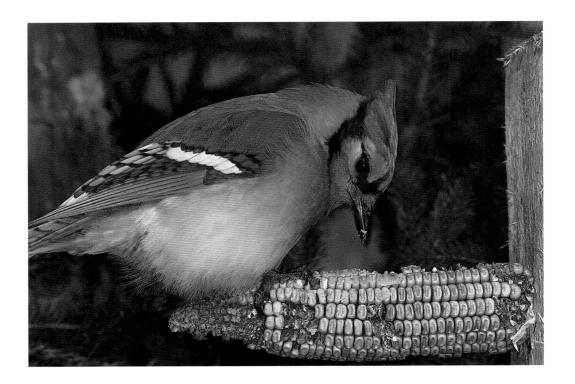

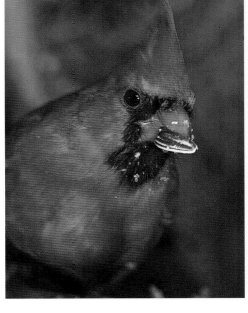

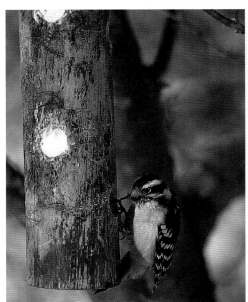

Blue Jay on Corncob. *This jay was photographed through a window from inside the house as it came to the feeder. Three manual electronic flashes were used, two to illuminate the bird and one for the background. The two remote flashes were synchronized to the flash connected to the camera by small slave units. Nikon F2, 200 mm f/4 Nikkor, 25 mm extension tube, Kodachrome 25, 1/60 second at f/8.*

Cardinal with Sunflower Seed. *This bird was photographed using a similar flash set-up as that described opposite at a range of about two feet. The cardinal is studying his reflection in the lens. Nikon F2, 200 mm f/4 Nikkor, extension bellows, Kodachrome 25, 1/60 second at f/8.*

Downy Woodpecker at Suet Log. *Woodpeckers, chickadees, nuthatches, and many other visitors to backyard feeding stations are fond of suet. Here bacon drippings have been smeared into holes bored into a suspended log. Such feeders can easily be disguised to look like natural sites and careful positioning of the camera will leave the bait unrecorded.*

🦤 CAPE MAY *PHOTO HOTSPOT*

OVER THE YEARS, this has been one of the hottest birding spots in North America. Shaped like a giant funnel, Cape May collects migrants moving south along the Atlantic flyway and concentrates them at the tip, where there are usually plenty of photographers lying in wait. Here, birds are suddenly confronted with a great gap in the coastline—Delaware Bay, a thirty kilometer (eighteen mile) stretch of open water. They must fly across nonstop, or retreat inland to a longer but safer route. Some continue without hesitation. Others loaf about the shoreline, gathering energy or waiting for favorable winds. A strong

northwest wind can blow the birds helplessly out to sea, and consequently causes great numbers to pile up at the end of the cape until the weather changes. Cape May offers interesting birding at any time with good numbers and variety, but the last half of the year is best. Exceptional aggregations of species begin in August, when tree swallows seem to be swirling everywhere. Their numbers build steadily as they are joined by other swallow species. Later in the month, the first wave of eastern kingbirds washes over the suburban neighborhoods of the cape. Waves of various species follow all through the fall—bobolinks, kestrels, ospreys, soaring hawks, merlins, and peregrine falcons. Marshes back from the bay are frequented by dowitchers, turnstones, sandpipers, yellowlegs, and many other shorebirds, as well as diverse waterfowl. Here photography is possible from mobile hoop blinds and floating blinds. Throughout September, migrating northern flickers pass in a steady stream of up to 50 birds per minute along the beach, providing an excellent opportunity to set up a photogenic resting perch and take a concealed position nearby. Migration tapers off by the end of November with a final rush of American woodcocks, most likely found by day in hedge rows back from the beach. If you are arriving by air, Philadelphia is the closest major center. The best months are September and October.

quit the attempt. A nervous bird can rarely be photographed and it is likely to abandon its eggs and/or young with fatal results. If you have been cautious, the bird usually will return confidently, showing no concern for the blind.

INSIDE THE BLIND

Once the blind is in place, you cannot simply get into it and begin shooting. The bird will know of your presence even if it cannot see you. Someone needs to walk you into the blind and then leave carrying your jacket on a hangar held at arm's length. This ruse is enough to convince the bird of your departure. When the shooting session is over, don't leave the blind until your companion returns to pick you up so that the bird does not associate your presence with the blind.

You should allow the bird's first visit to pass without firing the shutter, particularly if it appears nervous. If it settles onto the nest to brood the young, it will not likely become alarmed by the sound of the camera. After a few exposures the bird normally will show no reaction, even to a high speed motor drive.

Usually one or two sessions of about three hours are sufficient to capture a variety of views of the parents and young. From an artistic standpoint, there is little to gain from further shooting and your continued presence increases the risk of nest failure. It is important to stop photography once the young have developed flight feathers as they are strong enough at this stage to

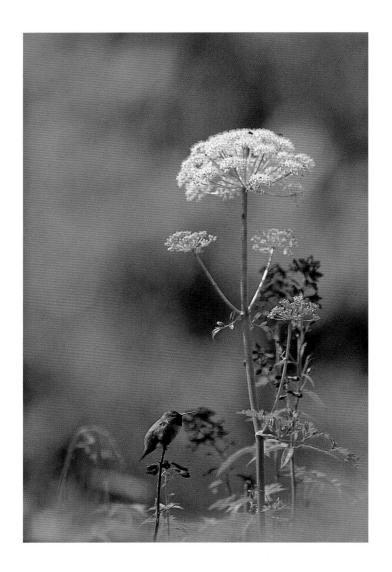

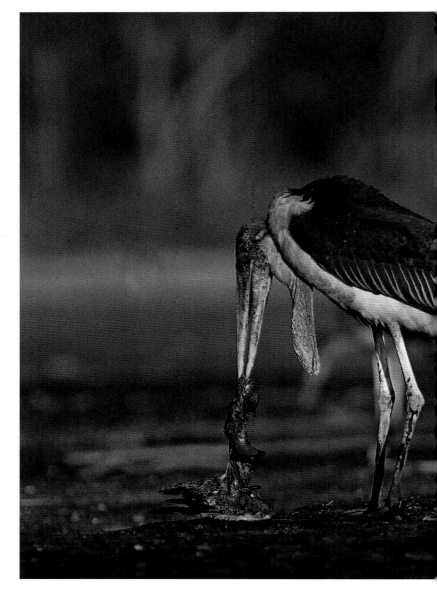

hop-fly prematurely out of the nest when you arrive to get into the blind.

AT GATHERING SITES

Away from the nest, photography is exciting, unpredictable, and more likely to yield dramatic images. And if caution is exercised, your impact on the bird's welfare is rarely of consequence. Birds are attracted in numbers at food sites, resting places, and courtship areas. Getting close to birds in these situations may be done by setting up a blind, using natural cover, or stalking. However you come into shooting range, you must first evaluate your impact on the subject's welfare. If all seems calm, proceed with necessary attention to sound composition and appealing lighting.

FEEDING SITES

Birds often forage in a routine manner, appearing at the same food source at a similar time each day. The more you observe birds, the more accurately you will be able to predict where and when to find them. Following are some examples of common areas where birds gather to feed.
• Sandpipers congregate on mud flats at low tide to probe for invertebrates that burrow into the mud and sand.
• Seed-eating birds (finches, chickadees, sparrows) will feed on composite flower heads once the seeds have developed. Sunflowers are valuable sites because it may take a week or more for the birds to eat all of the seeds.

Bag Blind. *As easily portable as an over-sized shirt, the bag blind is a handy method of concealment that is effective at natural feeding sites. You have to make camera adjustments slowly as the blind does not hide body movements.*

Marabou Stork with Lesser Flamingo, Lake Nakuru, Kenya. *The sheer number of flamingoes at Lake Nakuru attracts many predators, making it an excellent place to photograph such species as African fish eagles, marabou storks, and several species of vultures.*

Rufous Hummingbird, Colorado. *A thick patch of flowers in an alpine meadow is likely to attract hummingbirds. I set up my camera in the underbrush and waited for the birds to arrive. Hummingbirds visit certain patches at regular intervals, so patience is generally rewarded. Not knowing exactly where the birds will feed, you must take a position that gives a clear shot of several sites simultaneously. While you are waiting you can accustom yourself to the focusing range of the various targets.*

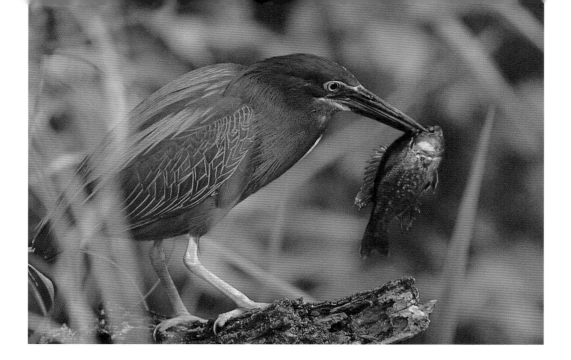

• Carrion-eating birds (crows, jays, ravens, vultures) are drawn to dead animals. Salmon spawning areas are attractive to bald eagles.

• Oystercatchers forage over shellfish beds at low tide, surf and white-winged scoters at high tide.

• Fruit eating birds (thrushes, waxwings, finches, parrots, etc.) are attracted to berry and fruit trees.

• Kingfishers are attracted to branches overhanging shallow pools where they can watch for prey while resting.

• Robins convene on freshly watered lawns to hunt for dew worms.

• Hummingbirds visit tubular flowers at regular intervals to siphon nectar.

There are ways in which you can enhance the photographic value of such sites. You might gather the spent fish at a salmon spawning stream into a small area near the camera or reposition fruit-heavy branches in front of an attractive background. Try hanging a hummingbird feeder among a patch of flowers to increase the frequency of their visits. Robins can be lured closer to the camera if you water your lawn and place several worms in one spot as bait.

COURTING AND TERRITORIAL SITES

When courting, birds display their finest plumages and most animated behavior.

• Members of the grouse family (including prairie chickens) gather on well-defined courtship arenas. Ruffed grouse display on special 'drumming' logs.

• Songbirds use a small number of perches from which they habitually sing, especially in habitats where perches are scarce (prairies, marshes).

100

House Wren, New York. *I set up this perch near the wren's nesting site hoping that it would take the opportunity to do some singing when it wasn't feeding the young. It welcomed the chance. Canon T90, 500 mm f/4.5 L Canon, Fujichrome 50, 1/250 second at f/4.5.*

Green-backed Heron, Everglades, Florida. *This bird habitually fished at a small pool in Everglades National Park. Like most green-backed herons this one was very tolerant of humans. After a short wait, I was rewarded with a few shots of its catch. Canon T90, 500 mm f/4.5 L Canon, Fujichrome 50, 1/125 second at f/4.5.*

🦤 CALLING BIRDS TO THE CAMERA

USING NATURAL SOUNDS to lure birds within camera range is an exciting and fast acting procedure. Caution, however, is necessary to avoid disruption of the bird's normal activities. When used in the springtime to lure songbirds, you will be able to capture them in their most brilliant plumage, and when they venture near to investigate the sound, they will be in their most alert postures, usually out in the open, offering clear views in strong light.

The calls are most effectively produced using a portable, cassette tape recorder or, better yet, the cassette deck installed in your car, if you are working in this way. Commercial tapes are available (see the Appendix) that arouse the curiosity of many types of birds. Using species specific territorial calls is not advised. They may sometimes draw in members of that species, but no others. By far the best call, especially for songbirds, is that of the screech owl. A natural enemy of any animal the size of a sparrow, its call arouses the curiosity of any songbird within earshot and lures it toward the camera position.

Although calling techniques can be used while on foot, you should work from a roadside vehicle which is readily accepted by the bird, affords mobility, and provides a spacious blind from which to work. Calling for ten minutes at any one spot is long enough to bring in a subject; longer sound playing will seldom yield results. Concentrate on areas of diverse habitat—mature forest interspersed with brushy second growth and meadow, for example. Position the vehicle near a single, obvious, isolated perch which allows good coverage from the camera. Avoid stopping where there are overhead wires and tall trees as the birds will perch high and out of range. From dawn to early mid-morning, you will encounter the most response to calls and have the most attractive light. Play the call at low volume (about the level of quiet speech) steadily for five to ten minutes. Calling at high volume should not be done; it is unconvincing and may even drive the subject away. Stay concealed behind the window camouflage and use the longest lens you have.

At low volume, a screech owl call initially causes about the same commotion as a real owl, but its effectiveness falls off quickly. During the nesting season, be sure to limit your calling to ten minutes in any one spot to avoid keeping a parent away from the nest for a longer period than normal. Species specific territorial calls should not be used; they can create too much stress for the bird occupying the territory and they are less effective than the owl call, anyway.

• Woodpeckers will tap out their territorial claims on especially resonant trunks.

Do not attempt photography of any bird engaged in courtship display at the nest site until after the eggs have hatched.

ROOSTING SITES

Birds must feel safe from predators during the considerable periods when they are resting and cleaning their plumage. Such areas, usually near water, may attract birds in large congregations so that a 'safety in numbers' strategy also operates. With careful observation you will be able to pinpoint sandbars, small islands, rocks, pilings, and floating logs where birds come regularly to roost. Points of land connecting migration routes over open water (such as High Island, Texas; Cape May, New Jersey; and Point Pelee, Ontario) are also productive situations. You may enhance the attractiveness of a site by putting out decoys— ducks, geese, sandpipers, and herons which can be purchased in rod and gun shops.

Common Golden-eye Ducks, British Columbia.
This contented family spent sunny afternoons warming themselves on a floating log. The liquid moat surrounding their place of refuge made it difficult for predators to approach undetected. Wearing chest waders, I drew near them in the open and kept a sufficient distance so as not cause alarm. Canon T90, 500 mm f/4.5 L Canon, Kodachrome 64, 1/500 second at f/4.5.

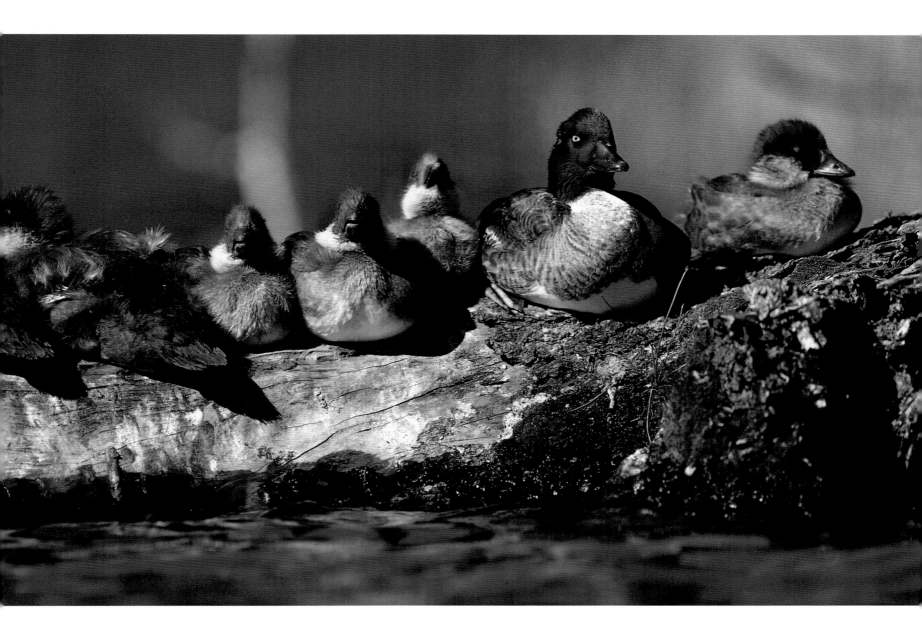

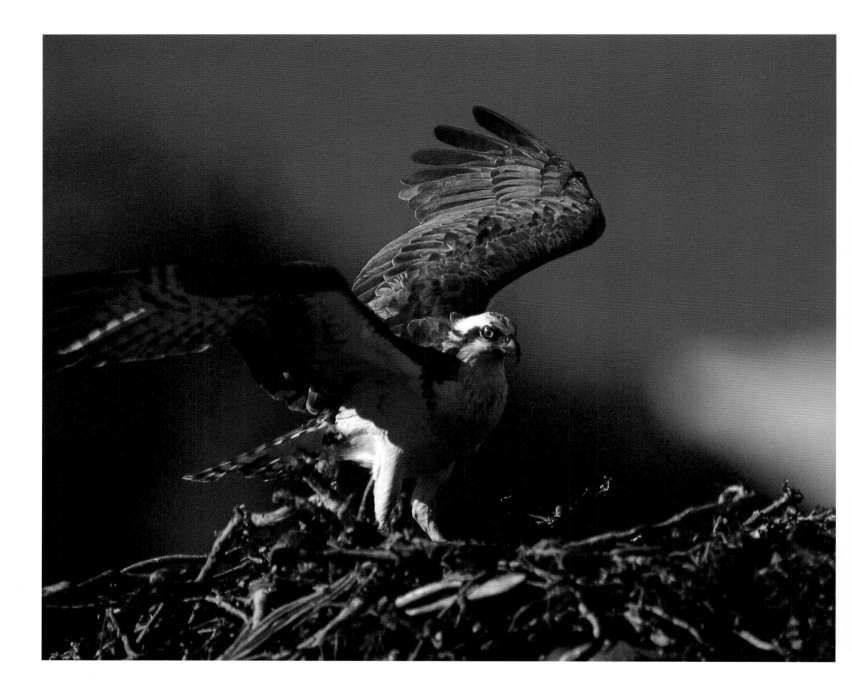

STALKING BIRDS

Away from the nest, where the action is unpredictable, a fixed blind may be less advantageous than working in the open or in a mobile blind. Camouflage yourself appropriately, or if using a blind, get into it out of sight of the bird. Wetlands provide plenty of subjects which tend to be relaxed by the extra safety that the water affords. When using the hoop blind, much of your body is underwater, the blind is folded up and floating on the surface, and your approach can be made in silence. Take the following precautions when stalking.

• Plan your approach before setting out, taking into account the lighting, nature of the terrain, and abundance of subjects.

• Don't set a course that will cut off the bird's escape route. This will cause it to become anxious and precipitate departure.

• Stay low.

• Be deliberate in your movements. Stop if the animal shows suspicion. Continue when it relaxes.

• If working from a mobile blind, once you come in sight of the subject, do not to move at all for 1/2 hour or longer. This leads the birds to believe that you are a natural part of the environment (a log or other floating debris). They will then tend to ignore your subsequent cautious approach into shooting range.

FLIGHT PHOTOGRAPHY

Only by anticipating the flight path of the bird, can you ready yourself and the camera in time to make a successful image. This can be done by creating staged situations which cue the bird or by developing a knowledge of its airborne habits. The photography of bald eagles provides excellent examples of both types of approach. On Vancouver Island, eagles are accustomed to following fishing boats, waiting for handouts. Photographers take advantage of this behavior by baiting eagles to their cameras, using the fish as it floats in the water as the focusing and framing reference. Where eagles gather along streams to feed on spawned salmon, nature sets the stage but the strategy is similar in that the photographer is able to anticipate the bird's flight path. Contrived or natural staging techniques can be utilized anywhere birds gather—nests, backyard feeders, etc. Following are general tips for both manual and auto-focus procedures.

• Keep the camera on a tripod with loosened controls. This produces smoother panning and reduces fatigue.

• When choosing a shutter speed, keep in mind that the larger the bird, the slower are its movements but not necessarily its flight speed.

• Much of a bird's motion can be stopped by panning along the flight path. When panning, squeeze off the shots gently, being sure to follow through after each one.

• You can 'trap' focus on a flying bird by pre-setting the focus distance, following the bird in the viewfinder, and releasing the shutter an instant

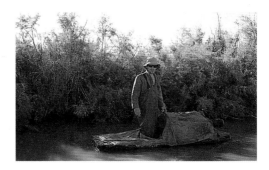

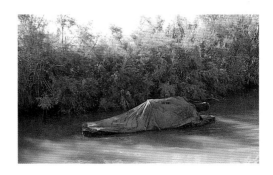

Floating Blind. *A floating blind allows a silent, smooth approach. This one is made of a sheet of styrofoam sandwiched by two sheets of plywood and covered with a camouflaged fabric cowling.*

Osprey, Isla Benito, Mexico. *After observing the osprey landing, I was able to prefocus on the portion of the nest where it was first likely to appear when returning. I framed the scene to allow ample space to capture the outstretched wings and timed the shutter release by watching the bird approach through a hole in the blind. Canon A2, 400 mm f/2.8 L Canon, 2x teleconverter, Ektachrome Lumiere, 1/500 second at maximum aperture.*

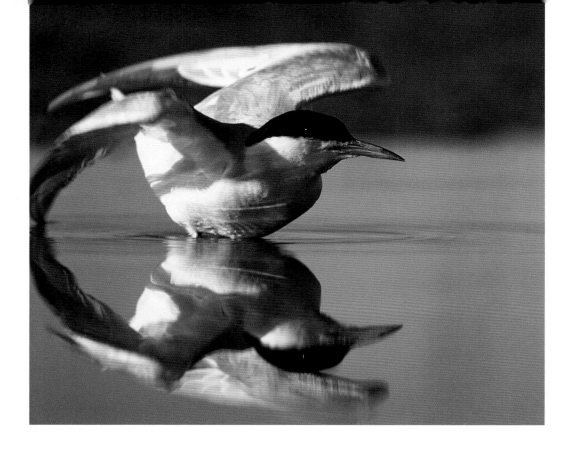

Common Tern, Oregon. *Unlike most birds, the tern will raise its wings slowly before taking flight, offering a dramatic pose of several seconds for the photographer. A benefit of photographing birds on the water is the natural light reflected from the surface that illuminates the shadow areas of the bird. Nikon F2, 400 f/5.6 ED Nikkor, Kodachrome 64, 1/ 350 second at f/5.6.*

Cattle Egrets, Tsavo National Park, Kenya. *I used a slow shutter speed to intentionally blur this flock of egrets, panning along with them as they flew past. Canon T90, 500 mm f/4.5 L Canon, Fujichrome 50, 1/15 second at f/22.*

before it reaches maximum sharpness. Practice helps.

• For stopping action with slower shutter speeds, try to catch the bird just prior to landing when it is almost motionless with wing and tail feathers dramatically spread to break its momentum.

• The flight path is most easily anticipated just after take-off. Keep in mind that the bird prefers to launch into the wind. The space into which the bird is headed can be framed and the shutter tripped as the bird raises its wings to leave.

• Study the flight patterns of each species, especially take-offs and landings which present the best opportunities.

• Position yourself along flight paths to popular roosting spots, feeding areas, or other sites where birds gather.

• Even the most experienced photographers achieve only a small percentage of successful shots, so set your motor drive at its highest speed and shoot a lot of film.

• Experiment with the dramatic effects of blurring that result from slow shutter speeds and smooth panning of the camera.

AUTO-FOCUS ACTION SHOTS

To use automatic focusing, you have to keep the camera's auto-focus sensor trained on the bird's head. This requires both practice and good fortune. If the sensor goes off target, the lens will begin a focus search throughout its range (to infinity and back) and you will miss the opportunity

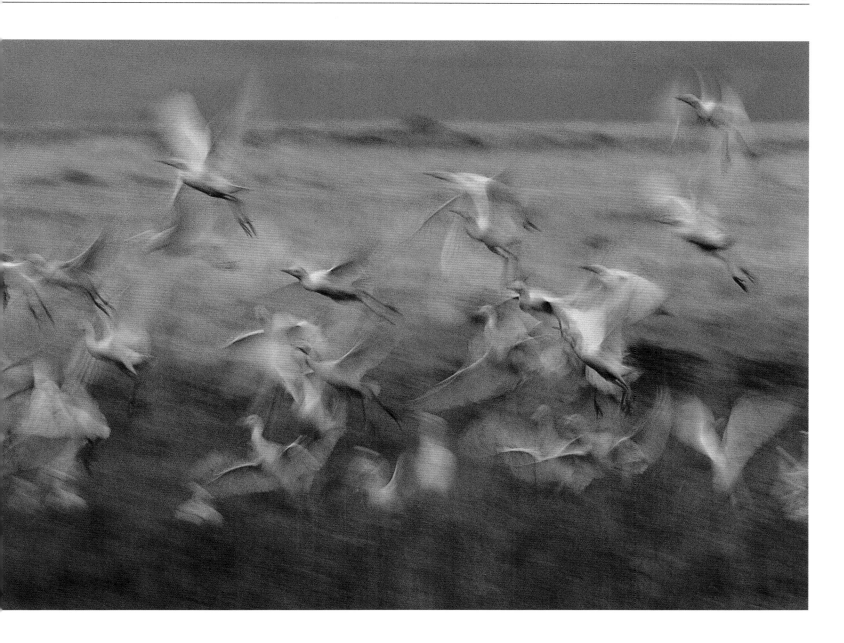

Black-necked Stilts, Moses Lake, Washington. I had already completed framing and manual focus on the stilt's eye when, to my amazement, another stilt alighted. Mating only lasted a few seconds and I kept the motor drive chattering without let-up. *Canon T90, 500 mm f/4.5 L Canon, 1/350 second at f4.5.*

Magnificent Frigatebird, Isla Isabel, Mexico. A large, slow-flying bird can be easily be brought into focus, especially when hovering above its nest site as this frigatebird was doing. Manual or continuous auto-focus techniques are effective with such species. *Canon A2, 400 mm f/2.8 L Canon, 1.4X teleconverter, Ektachrome Lumiere 100, 1/750 second at maximum aperture.*

Black Skimmer, Florida. This species skims small fish and crustaceans from the water's surface by dragging its lower bill in flight. It often retraces the flight path giving the photographer opportunity to pre-set the focusing range and framing parameters. *Canon T90, 500 mm f/4.5 L Canon, Kodachrome 64, 1/30 second at f/8.*

Reddish Egret, Texas Coast. Reddish egrets dart about the shallows when they feed, stopping here and there to strike at prey. This is a good situation to use auto-focus on the continuous focus setting. Most systems can keep up with this kind of action provided you are able to keep the focusing sensor fixed on the target—not always easy when using super telephoto lenses. *Canon T90, 500 mm f/4.5 L Canon, Fujichrome 50, 1/350 second at f/4.5.*

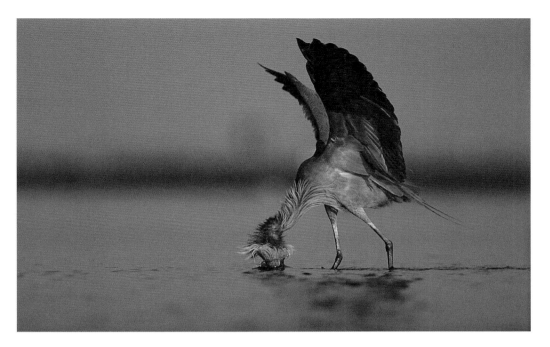

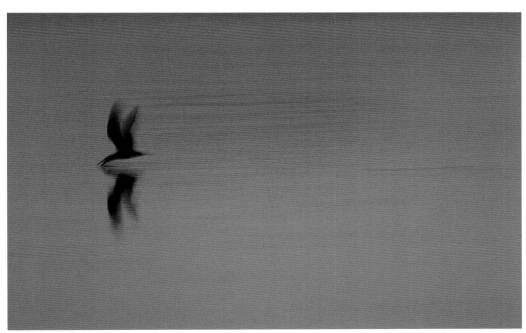

for the shot. Although some cameras offer several sensor locations from which to choose, most offer but one in the middle of the frame which restricts important design choices.

Set auto-focus on continuous mode. Although the camera normally cannot keep up with a bird moving directly toward the camera, it works well for birds moving across the field of view as then the focus can lock onto the subject making a long sequence of motor-driven images possible. On advanced cameras, a 'predictive' focusing feature calculates the speed of an approaching subject and predicts correct focus, compensating for delays in the shutter mechanism. Some cameras offer 'trap' focus which automatically fires the camera when the bird passes through the focus zone which you have selected beforehand. Many birds are too quick for the trap, even if you are able to keep the focusing sensor on the subject as it approaches.

Like other aspects of photographing birds, flight photography is not always easy. This challenge is one of the many reasons why wild bird photography has become so popular with so many people. Let's do our best to help restore to birds and other wild creatures their share of the planet's resources. It will mean not only that we continue to have beautiful subjects for photography, but a healthier environment for everyone.

Appendix

SUPPLIERS OF SPECIALIZED PRODUCTS

A. Laird Photo Accessories, P.O. Box 1250, Red Lodge, MT 59068, 1-406-466-2168. Pads for tripod legs and rain hoods for camera/long lens combinations.

B & H Photo-Video, 119 West 17th Street, New York, NY 10011, 1-800-947-9970. The mail order company of choice for professional photographers. Call for a catalogue, or consult the back pages of *Popular Photography* magazine.

DB Design, P.O. Box 1571, Forestville, CA 95436-1571, 1-800-496-3129. Floating hoop, freestanding, and mobile blinds. Call for a free catalog.

Johny Stewart Wildlife Calls, P.O. Box 7594, Waco TX 76714-7594, 1-817-772-3261. Screech owl call cassette tape and others.

Leonard Lee Rue Enterprises, 138 Millbrook Road, Blairstown, NJ 07825, 1-908-362-5808. A variety of specialized outdoor photography accessories (not cameras or lenses), Kimac individual slide protectors, outdoor photography guides and natural history references. Call or write for a catalogue.

Kirk Enterprises, Inc., 107 Lange Lane, Angola, IN 46703, 1-800-626-5074. Specialized camera accessories including car window mounts, bag blinds, ball heads, and beanbag supports.

BIRD FINDING AND IDENTIFICATION GUIDES

A Bird-Finding Guide to Canada, edited by J.C. Finley, Hurtig Publishers Ltd., Edmonton, 1984.

Field Guide to the Birds of North America, 2nd ed., National Geographic Society, Washington, D.C., 1987. (This is the top-rated field guide.)

A Field Guide to the Nests, Eggs and Nestlings of North American Birds, Colin Harrison, Collins, Toronto, New york 1984.

A Guide to Bird Finding East of the Mississippi, 2nd ed., O. S. Pettingill, Jr., Oxford University Press, New York, 1977.

A Guide to Bird Finding West of the Mississippi, 2nd ed., O. S. Pettingill, Jr., Oxford University Press, New York, 1981.

Guide to the National Wildlife Refuges, revised edition, Laura Riley and William Riley, Collier Books, New York, 1992.

Peterson Field Guide: A Field Guide to Birds Songs: Eastern and Central North America, 3rd ed., 2 cassette tapes, Cornell Laboratory of Ornithology, Houghton Mifflin Co., Boston, 1983.

Peterson Field Guide: Bird Songs: Western North America and the Hawaiian Islands, 3 cassette tapes, Cornell Laboratory of Ornithology, Houghton Mifflin Co., Boston, 1975.

Photo Traveler, Post Office Box 39912, Los Angeles, California 90039. This monthly newsletter, written by photographers, provides invaluable information on shooting logistics for wildlife, including birds, all over North America. Back issues are available.

Photograph America Newsletter, 1333 Monte Maria Avenue, Novato, California 94947-4604. Same concept as *Photo Traveller* (above) but the information is more specific.

BIRD PHOTOGRAPHY REFERENCES

The Adventure of Nature Photography, Tim Fitzharris, Hurtig Publishers Ltd., Edmonton, 1983.

Art of Photographing Nature, Art Wolfe and Martha Hill, Crown Publishing Group, New York, 1993.

Bird Photography Basics, Arthur Morris, Bird Watcher's Digest, Marietta, Ohio, 1992.

Calling Songbirds to the Camera, Richard E. Faler, Jr., Beaver Pond Publishing & Printing, Greenville, PA, 1990.

How to Photograph Birds, Larry West and Julie Ridl, Stackpole Books, Harrisburg, PA, 1993.

Hummingbirds of North America: Attracting, Feeding and Photographing, Dan True, University of New Mexico Press, Albuquerque, 1993.

Nature Photography: National Audubon Society Guide, Tim Fitzharris, Firefly Books, Toronto, 1996.

Stalking Birds with Color Camera, Arthur A. Allen, National Geographic Society, Washington, D.C., 1951.

Wild Bird Photography, Tim Gallagher, Lyons and Burford, Publishers, New York, 1994.

BIRD BEHAVIOR REFERENCES

The Audubon Society Encyclopedia of North American Birds, John K. Terres, Alfred A. Knopf, New York, 1980.

Fundamentals of Ornithology, J. Van Tyne and A. J. Berger, John Wiley and Sons, New York, 1976.

A Guide to Bird Behavior, vol. I, Donald W. Stokes, Little, Brown & Co., Boston, 1979.

A Guide to Bird Behavior, vol. II & III, Donald W. Stokes and Lilian Q. Stokes, Little, Brown & Co., Boston, 1983, 1989.

Life Histories of North American Birds, (in 23 volumes), Arthur Cleveland Bent, Dover Publications, Inc., New York, 1961. An indispensable reference if shooting at the nest.

PRODUCED BY TERRAPIN BOOKS
Santa Fe, New Mexico